IMAGES
of America
SOUTHWEST DENVER

FROM DENVER TOWARD THE SOUTHWEST, 1908. In this photograph, a newly ascendant Denver reigns supreme over the land, having triumphed in a battle to absorb surrounding towns into a consolidated city and county government on November 15, 1902. At that time, even city leaders could not have imagined that a half century later, Denver would set its sights toward Loretto Heights, seen here rising in the distance, seven miles from the capitol building, from where this photograph was taken. In the foreground, Lincoln Street stretches southward with St. Mark's Church and its Norman tower at Twelfth Avenue. A dominant Denver General Hospital is in the middle at Sixth Avenue and Broadway. (Denver Public Library Western History Collection.)

ON THE COVER: Taken in 1913, this photograph of the eighth-grade graduating class of the Valverde School includes Claude James "C.J." Allen, standing in front of and just to the left of his teacher. Their school was perched on a hill southwest of present-day South Navajo Street and West Exposition Avenue in a building that had been constructed in the town of Valverde in 1890. Allen witnessed Denver annex the once separate town of Valverde by 1902 as the city grew in all directions. The new city and county of Denver would lie dormant until 1941 when it began to expand quickly, especially southwestward. (Author's collection.)

IMAGES of America
SOUTHWEST DENVER

Shawn M. Snow
Foreword by Jeanne Faatz

ARCADIA
PUBLISHING

Copyright © 2016 by Shawn M. Snow
ISBN 978-1-4671-2406-5

Published by Arcadia Publishing
Charleston, South Carolina

Printed in the United States of America

Library of Congress Control Number: 2016949275

For all general information, please contact Arcadia Publishing:
Telephone 843-853-2070
Fax 843-853-0044
E-mail sales@arcadiapublishing.com
For customer service and orders:
Toll-Free 1-888-313-2665

Visit us on the Internet at www.arcadiapublishing.com

To the good people of southwest Denver

Contents

Foreword		6
Acknowledgments		7
Introduction		8
1.	Growing a New Home	11
2.	The Earth Gave More Than Gold	15
3.	They Had Dirt under Their Fingernails	27
4.	Farmland No More	51
5.	Ranch Houses, Not Ranches	65
6.	Denver Grows Southwest	83
7.	Planting a Future Denver	113
8.	The Undiscovered Country	119
Bibliography		127

Foreword

In 1968, my family discovered southwest Denver. It was time to buy a house. The same Hutchinson ranch home, built in several subdivisions in the Denver area, sold for nearly 10 percent less in the southwest area than in the southeast. Moreover, southwest Denver emphasized families. It had more churches than bars. Convenience to good schools, grocery stores, and diverse retail and a theater added to its attractiveness.

Overall, southwest Denver has been an extraordinary place to live and raise a family. It has strong neighborhoods, homes on large lots, nearby schools, and beautiful parks. From the beginning, community members sought activities for children and parents, boosting the area's vitality and cohesion. The YWCA Y-Wives program, with over 100 adult members, rented church space to offer classes for women and a play school for their young children. Also, the YMCA leased southwest Denver parkland to build a new facility, then a unique arrangement for the city. Two court decisions temporarily set back momentum. Court-ordered de-annexation of Governor's Ranch and Westridge and court-ordered Denver school desegregation with mandatory busing caused logistical challenges for many residents. The former upended plans of Denver city workers who purchased homes to comply with Denver's residency rule. The latter upset many families whose children could no longer walk to their neighborhood school. Some moved to other cities.

Through pictures, Shawn Snow has documented the rise of southwest Denver, including these stories and a wide variety of other events, helping to tell the history of southwest Denver from 1880 to 1980. For as long as I have known him, he has expressed keen interest in land use policy and historical events. Annexation was one such crucial issue. In my role as Denver city councilwoman, I benefited from his exceptional understanding of boundary changes and the impact on residents.

Today, southwest Denver has a resurgence of young families. It remains one of the most affordable areas in Denver. I am grateful Shawn Snow has shown how the past decades have contributed to the remarkable development of our beloved southwest Denver.

—Jeanne Faatz
State representative, District 1, representing southwest Denver, 1979–1998
Denver city councilwoman, District 2, representing southwest Denver, 2003–2015

Acknowledgments

Writing this book has been an odyssey of fits and starts over the past decade. The history contained herein is considered as non-history by some because it does not generally cover anybody famous or particularly cover dramatic points in time. It is, in its truest form, the story of everyday people and places with narratives that have been hidden in closets, boxes, and albums and not always in library archives or newspapers. It has come together by adding everything up that I could find and then weaving a story into a cohesive narrative with the pictures at hand into the story of southwest Denver. It is an important story.

The completion of this volume would not have been possible without the considerable attention and assistance provided by Michael Vincent and Aaron Marcus. You two believed in my vision and never said no in providing technical and research assistance as well as encouragement. To you, I am forever indebted, as this book was not easy to put together. My urban planning comrade of 20 years, Ken Schroeppel, produced the wonderful maps in this book. Photographer Minka Ricker took the modern photographs for this volume to help round out the story, especially when no historical photographs could be found. In addition, the late Ivan Rosenberg, publisher of the *Southwest Denver Herald Dispatch*, kindly responded to my insistence that his warehouse might contain old boxes of photographs from his newspaper. We found some, and this book benefited from his kind donation of his life's work. And after digging in every nook and cranny I could think of across southwest Denver, I ended up with too many pictures. Editing photographs down was painful, but the treasure trove of images I eventually did assemble would not have been possible without the kind assistance and vision of the following individuals, in no particular order: Jack Ballard, Bonita Hutcheson, Regina Drey SL (Sisters of Loretto), Elizabeth Cook, Holly Geist, Melissa VanOtterloo, Laura Ruttum Senturia, Laura Meeks, Coi Drummond-Gehrig, Vickie Makings, David Forsyth, Atom Stevens, Diane Snow, Kevin Snow, Jim Peiker, Louis Feher-Peiker, Brother Emmett Sinitiere and Brother George Van Grieken, Clare Harris, Neal Bamesberger, Robert Vanliere, Marilyn Douglas, Sue Atkins, Newell Grant, Tom Noel, Judy Durzo, Ellen Daugherty McMichael, Mary Taft, Christopher Erskine, Ross Webster, Ryan Mulligan, Sheryl Sullivan, Karen Wilborn, Melvin G. Garcia, Lynda Heckendorn, Lyle Miller, Ginger Reichert, David Weist, Jeanne Faatz, Dana Montano, Kevin Flynn, William Marlowe, Natalie Shilstut, Michael Collins, Patricia McKinnon, Judi Wright, Win Ferrill, Bob Charles, and Bill Arndt.

Many pictures in this volume can be attributed to the following: the Denver Public Schools (DPS); Denver Water (DW); *Denver Post* (DP); Denver Public Library Western History Collection (DPL WHC); History Colorado (HC); author's collection (AC); De La Salle Institute Archives, San Francisco/New Orleans District, Napa, California (DLSI); Grant Family Photos, All Rights Reserved (GFP); Archives and Special Collections, Regis University, Denver (RU); Minka Ricker Photography (MRP); Mary Taft collection (MTC); Good Shepherd Lutheran Church (GSLC); Mulligan family collection (MFC); Presbyterian Historical Society (PHS); and the *Southwest Denver Herald Dispatch* (SWDHD).

All years in parentheses refer to either the year a town or site was founded or the year that a building was constructed.

INTRODUCTION

A strong sense of place is the hallmark of any community. Sometimes, that sense of place happens organically over time. Other times, it is the result of something new, written on a landscape whose trajectory changed through a sudden and somewhat unexpected and powerful tool: annexation. Thus is the tale of large swathes of unincorporated Arapahoe and Jefferson Counties—a once rural setting with its own hopes and desires forever altered by the big city next door. On one side of the border sat Denver; on the other, the open frontier. For the purposes of this book, southwest Denver is therefore defined as the areas brought into the city during a spate of hyperaggressive annexations of lands between 1943 and 1973. Prior to this time, Denver's boundary had stood frozen since 1902. The boundaries tended to follow the township and range system, creating a compact city and infusing citizens with a very clear idea of where the city limits ended.

The story of southwest Denver is not particularly unique when compared in a general sense to the story of growth patterns that gripped American cities during the 20th century. The growth of cities after World War II brought forth an unprecedented decentralization from urban areas as pent-up demand for new housing was found in suburbs across the nation. Within the blink of a few decades, exploding populations picked up and pushed out from the perceived cramped conditions and decay of the "inner city." This was facilitated by cheap gas, automobiles, and federal laws that allowed for ease in purchasing a newly constructed suburban dream home in countless new subdivisions.

Denver was no different. For the area that would become known as southwest Denver, places such as the Davis Ranch, Whiteman Ranch, and Grant Ranch were morphed into the Mar Lee subdivision, Harvey Park neighborhood, and, appropriately, Grant Ranch and Governor's Ranch subdivisions. These are but a few examples that symbolize the relentless transition of the once rural landscapes into instant cities, brought about by Colorado's burgeoning population. A decentralized "garden" neighborhood with ample open space, large yards, and strip malls accessible by car was the ticket to success. Southwest Denver is a prime example of this type of development.

Hoping to capitalize on the sudden exodus from "old" Denver to "new" Denver, the city began an aggressive annexation campaign. Areas that were once on the outskirts of town suddenly found themselves sitting up against new subdivisions. Institutions that had located far from the city, seeking rural locations, such as Fort Logan and Loretto Heights College, were on the annexation horizon. Rural sections of Arapahoe County such as Westwood (Garden Home), College View, Scenic View, and Sheridan quickly sought annexation to Denver in the hopes of receiving better services such as paved roads, sidewalks, city water, and sewers—programs that were severely lacking in the rural county.

For Denver itself, the writing was on the wall. In a governmental system set up to provide services that are mostly funded through property taxes and sales taxes, Denver felt it needed to annex these new developments to keep city coffers full and to control haphazard development. With a massive disinvestment occurring in downtown Denver after World War II, both retail and business interests were following the exodus of the middle-class population to the edge of town and to new cities that were suddenly incorporating all around Denver, including Cherry Hills Village (1945), Greenwood Village (1950), Commerce Town (1952), Glendale (1952), and Bow Mar (1958). Denver made its first residential annexation of land since 1902 by absorbing Mountain View Park at Alameda Avenue and Federal Boulevard in 1943. Thus began a 30-year odyssey that pitted "evil" Denver against "innocent" Arapahoe and Jefferson Counties. The narrative was set.

The city and county of Denver, serving as state capital and also the largest city in Colorado, is a rather unique governmental entity in the state. Created with the consolidation of several adjacent cities in 1902 by a change to the state's constitution, the city broke away from Arapahoe County and absorbed towns such as Valverde, Montclair, Globeville, and Berkeley (now Denver neighborhoods). In so doing, it eliminated duplicate city and county offices and became a model in efficiency with one unified government. With plenty of room to grow within its boundaries, it saw no need to expand beyond these borders. After 1941, however, enormous tension was created with the adjacent counties, as the city was determined to grow in area through annexation. In Denver's case, not only would new land cease being in the other county once the annexation took place, but the land would also become part of the unified Denver school district. Over the ensuing years, the animosity and fighting that took place in courtrooms over these tactics led to tremendous growth for Denver. The city prevailed in most of its battles with Arapahoe County during the 1950s and 1960s, but its luck ran out in the 1970s, as it lost most of its annexation battles with Jefferson County. With its problematic annexation policy, the city pursued an unprecedented expansion that continued unabated until December 25, 1973. During that time, the city doubled in size overall, reaching nearly 120 square miles. Denver's fortunes in annexation were ultimately restricted in 1974 by the voter-approved passage of the Poundstone Amendment. It effectively prohibited Denver from ever annexing land again without the consent of a majority of voters in the county where the city wished to annex. Generally, individual landowners and homeowners alike had little problem joining Denver to receive superior water and other urban services at a lower cost and lower property tax rate. Denver attempted to find support for an alternative constitutional amendment to Poundstone—a boundary control commission. This compromise, which was also approved in 1974, allowed for the "modernization of annexation and consolidation proceedings in the Denver metropolitan area." The election showed that although anger toward Denver and its annexation policies was strong, some give and take was possible. In the end though, Denver was treated more like a county than a city as related to its annexation abilities. Just as a county could not annex an adjacent county's land without a vote, neither could Denver.

The election of 1974 was also influenced by the advent of forced busing for integration in September of that year within Denver's schools. The city knew that after the election, its annexing capabilities would be nearly nonexistent, even with the possibility of relying on a new boundary control commission. Therefore, Denver managed to annex almost 15 square miles (9,468 acres) of land in 1973 alone. There were 34 separate annexations undertaken—18 of them were in Jefferson County (6.5 square miles or 4,244 acres). Most of these final annexations ended up being challenged in court. Of these challenges, Denver eventually had to return 3,326 acres to Jefferson County.

Ultimately, the city's borders were frozen in time, and with successive court losses, the convoluted, arbitrary, and confusing boundary of southwest Denver was created. While a sense of place is quite apparent in the areas that are within the city and county of Denver, it becomes less visible in areas and neighborhoods that are split at a property line instead of a major street—where neighborhoods and subdivisions are now divided between multiple jurisdictions, zip codes, and city appellations. Grant Ranch and Centennial Acres are but two examples.

As the city quickly annexed land, including parcels such as the Cook Ranch, Fehringer-Harriman properties, the Friendly Hills housing development, and Grant Ranch, Jefferson County commissioners plotted their course of action. To Denver, the thought of losing the land it had legally annexed in 1973 seemed unthinkable. After all, the courts had previously overwhelmingly supported the city's annexation campaigns in Arapahoe County. Jefferson County contested the use of so-called flagpole annexations to reach Fehringer-Harriman and Friendly Hills. The court also questioned the exact legal description of the land to be annexed in Grant Ranch as well as the procedural issue that not all landowners were consulted prior to the annexations taking place. However, even with the prospect of desegregation in the city of Denver, residents of Friendly Hills, among others, vociferously supported staying in Denver but were denied that chance time and again by the court system.

Additionally, the large Grant-Witkin parcel (Grant Ranch) had been annexed in two pieces. The smaller 440-acre parcel was deemed legal, while the larger 1,767-acre parcel was deemed illegal and ultimately de-annexed. The city retained numerous other annexed sites, including the Cook site (303 acres, annexed November 20, 1973) and the new Park West development (80 acres, annexed January 10, 1973). For other de-annexed subdivisions, Jefferson County would not agree to residents' demands for a vote on coming back into Denver. County officials were not about to let Denver take back Grant Ranch, which had been part of the city for over seven years. Consequently, the city lost its $175 million Southwest Plaza Mall—that it had zoned and planned for—in 1981 along with subdivisions like Governor's Ranch and Westridge, while "lucky" residents in Glenbrook and Park West north of West Belleview Avenue remained in Denver.

Consisting almost exclusively of single-family-home subdivisions, southwest Denver is generally considered to be equal to about 18 square miles of land south of West Alameda Avenue, west of the South Platte River and stretching to numerous convoluted city limit boundaries to the south and west that remained within Denver. While some areas had small truck farms among huge ranches as early as 1900, such as Garden Home and College View, a majority of development now visible in numerous southwest Denver neighborhoods dates to the years following World War II.

Southwest Denver was considered by many to be *the* place to live between the 1950s and 1980s as it was a good, stable place to raise a family. The demographics of the area have changed dramatically since that time, and it is now among the very few affordable areas left within the city limits. Ethnically homogenous for much of its existence, southwest Denver today is among the city's most diverse regions. Areas along South Federal Boulevard are full of signs written in Spanish and Vietnamese, used by businesses that began to replace mainstream establishments beginning in the 1980s. While the largest high school in the area, Abraham Lincoln, was 85 percent white in 1968, it is now 95 percent Hispanic. An increasingly diverse Westwood was apparent in 1970 with a population that was 36 percent Hispanic, and is today about 85 percent Hispanic. Similarly, Harvey Park and Harvey Park South were 6 percent Hispanic in 1970, but today stand at over 50 percent Hispanic overall. With a total 2010 population of 101,625 residents, southwest Denver makes up about 17 percent of Denver's population. With stable neighborhoods, well-built homes, established schools, incredible views, beautiful parks and open space, hidden wonders of architecture and history, and easy access to the nearby mountains, southwest Denver celebrates its strong identity and sense of place. Not quite urban and not quite suburban, fortunate southwest Denver citizens definitely know where the city boundary ends.

Major subdivisions in southwest Denver's neighborhoods (defined in 2016 by the City and County of Denver, along with 2010 populations) include **Westwood** (15,486): Adams Park (1924), Belmont Park (1924), Kentucky Gardens (1938), Adams Gardens (1949), Irving Park (1949), Westlawn (1949), Westwood Park (1949), Dora Lea (1954); **Athmar Park** (8,898): Valverde (1882), Morristown (1884), Mountain View Park (1943), Athmar Park (1949–1950), Valverde Heights (1949); **Mar Lee** (12,452): Garfield Heights (1889–1893), Progress Heights (1926), Boulevard Acres (1938), Berry Hills (1947), Mississippi Heights (1948), Sheridan Park (1948), Mar Lee Manor (1950–1953), Hurley Heights (1951), Sheridan Manor (1953), Sunny Acres (1953); **Ruby Hill** (9,820): Manchester Heights (1889–1891), Florida Heights (1927), Garden Park (1943), Rose Acres (1944), Gunnison Heights (1950–1952), King-Houston (1952), Marland Heights (1952–1953), Green Acres (1952–1954), Perl-Mack (1954); **Harvey Park** (11,523) and **Harvey Park South** (8,393): Burns Brentwood (1946–1951), Green Meadows (1950), Sharon Park (1952), Harvey Park (1954–1958), Lakeridge (1955), Dartmouth Heights (1980), Bear Creek (1996); **College View** (6,498): Sheridan Heights (1888), Breenlow Park (1890), Boulevard Gardens (1925), Southlawn Gardens (1938), Alta Vista (1940), Evans Park Estates (1940); **Bear Valley** (8,889): Bear Valley (1961–1963), Academy (1975), Seven Springs (1978); **Fort Logan** (6,500): Centennial Acres (1957–1958), Centennial Estates (1957–1964), Trumac (1958), Bow Mar Heights (1962–1963), Pinehurst Estates (1962–1970), Bear Valley Heights (1965–1967), Westbridge (1997–1998); and **Marston** (13,164): Park West (1974–1978), Glenbrook (1979), Village West (1979), Grant Ranch (1987), Southwest Commons (1987), Quincy Shores (1989), Raccoon Creek (1996–1997).

One
GROWING A NEW HOME

MONTANA CITY MONUMENT CEREMONY, NOVEMBER 8, 1924. Holding a dedication ceremony 66 years after the earliest permanent settlement in what would become Denver, citizens gather with old-timers along the banks of the South Platte River just south of Evans Avenue. The marker, now lost, includes the words "to perpetuate the memory of the founding of Montana City, September 1858, the first organized town in the region and the beginning of Denver." Without Denver, there would be no southwest Denver. (DPL WHC.)

EARLY PIONEERS REMEMBER THE DAYS OF YORE. Frank Byers (left), son of *Rocky Mountain News* publisher William Newton Byers, joins John J. Reithmann for the Montana City monument dedication. Reithmann claimed to help settle Montana City, with 20 cabins, in fall 1858, before the town was permanently abandoned and its buildings moved to the new settlement of Auraria farther north that same year. (DPL WHC.)

DENVER GROWS UP AND OUT. This 1902 map of the newly created city and county of Denver shows that the city's area grew tremendously in the 44 years since its founding around November 22, 1858. The earlier Montana City had been established based on even earlier finds of gold along the Platte River drainage, including the Mexican Diggings area (1857), directly north near present-day Florida Avenue, and the Placer Camp, directly south near present-day Dartmouth Avenue. (Ken Schroeppel.)

RURAL AREAS SOUTHWEST OF DENVER, 1927. This topographical map shows the city and county of Denver as the darkest shades in the northern and eastern sections. The rest of the map shows the rural acreage of Arapahoe and Jefferson Counties with a bigger population center in the unincorporated community of Garden Home near Federal Boulevard and Alameda Avenue. In addition, homes are popping up across from Loretto Heights College and near Fort Logan. (US Geological Survey.)

URBAN AREAS OF SOUTHWEST DENVER, 1994. Between 1943 and 1973, Denver annexed thousands of acres and expanded in all directions, especially in southeast and southwest Denver. This topographical map shows the urban fabric and interface of numerous communities that adjoin the current boundaries of southwest Denver, often blurring the lines between who is a city resident and who is a suburbanite, even though housing patterns and street design seldom distinguish one from the other. (US Geological Survey.)

CITY SAVIOR OR THE BEAST NEXT DOOR? For 30 years, Denver relentlessly annexed areas of Arapahoe and Jefferson Counties to add about 23 square miles on its southwestern boundary. Many residents desired Denver's superior urban services in the areas of water, street paving, and schools. Until the city was stopped by the so-called Poundstone Amendment in 1974, neither hill nor dell, friend nor foe would stop its insatiable thirst to grow through annexation. (Ken Schroeppel.)

A PLEASANT VIEW FROM RUBY HILL, 2016. Since 1981, Denver's borders have been essentially frozen in time. No longer able to annex new retail to improve its tax base or to annex new residents to add to its population, the city was forced to look within for economic development opportunities. Consequently, the downtown and the center city of today have benefited from this ongoing reinvestment—a reversal from the postwar era when all eyes were on southwest Denver. (MRP.)

Two
THE EARTH GAVE MORE THAN GOLD

JOHN MCBROOM'S CABIN. Among the very first homesteaders of land that would become parts of southwest Denver was John McBroom, who staked his claim along Bear Creek just west of the Platte River. On his way from Fort Union to Fort Bridger in early 1858, McBroom had become mesmerized by the area. He returned in spring 1859 to build this cabin. His brother Isaac arrived with his wife, Emma, and young daughter, Eva, in 1860. (HC.)

EVA MCBROOM'S HIGH SCHOOL PHOTOGRAPH, 1880. Both McBroom brothers farmed adjacent claims of about 160 acres each near what would become South Federal Boulevard and West Hampden Avenue. Isaac's daughter, born March 3, 1859, made the long journey downtown to attend the new Denver High School, which had opened in 1874. She lived in a cabin with her family just west of Federal Boulevard. (DPL WHC.)

ISAAC MCBROOM FOUNDS SHERIDAN, 1887. Upon the announcement that a new fort would be built adjacent to his homestead claim, Isaac McBroom filed a subdivision plat in the southwest corner of his property that would become the future town of Sheridan. Isaac passed away in 1914 at the age of 84. While the preservation of his brother's cabin was unsuccessful, Isaac's home was removed and eventually reconstructed on the grounds of the Littleton History Museum. (HC.)

CLARK'S RANCH, JULY 21, 1899. Like the McBrooms, Rufus "Potato" Clark stands out for his decision to forgo prospecting and immediately turn his attention to growing crops and produce for a small but growing population. His large landholdings in Arapahoe County included much of what would become south and southwest Denver. His house stood in the Overland neighborhood, just downhill from Ruby Hill, at what would become 1398 South Santa Fe Drive. The view in this photograph is looking east from Loretto Heights. (DW.)

THOMAS SKERRITT, FATHER OF BROADWAY AND ENGLEWOOD. Thomas Skerritt claimed 640 acres east of the McBrooms in 1864 south of Sheridan Avenue (Hampden Avenue). Skerritt received permission to grade a road all the way to Denver along a major land section dividing line, which he called Broadway. His community of Orchard Place eventually incorporated as Englewood in 1903; that town would later join in an all-out annexation war with a growing Denver. (DPL WHC.)

CAMP NEAR THE CITY OF DENVER, JUNE 1910. Generous Denver citizens had given more than $33,000 to buy 640 acres of land about 10 miles southwest of Union Station, and the fort officially opened on October 31, 1887, just after the first infantry troops had arrived from Kansas. Lt. Gen. Philip Sheridan had personally selected the site, which was subsequently dubbed Fort Sheridan by locals. By April 1889, however, the secretary of war announced that the official name would be Fort Logan, after another Civil War hero and Memorial Day founder, John Alexander Logan, who had recently passed away. The name *Sheridan* remained nevertheless, with a new town growing adjacent to the fort as well as a main road connection to the north as well as to the east. The name *Fort Sheridan* would go to the camp near the city of Chicago. (Above, DPL WHC; below, Friends of Historic Fort Logan.)

WORLD WAR I AT FORT LOGAN, 1917. Architect Frank J. Grodavent was hired to begin construction on the field officers' quarters in 1888. The large houses dominated the open prairie and formed a semicircle around a 32-acre parade ground. Soon thereafter, a headquarters building, commissary, guardhouse, and other facilities were constructed. With the closure of Fort Laramie in Wyoming in 1889, Col. Henry C. Merriam arrived at Fort Logan with his 7th Infantry. Cavalry units arrived in 1894 along with the Army Signal Corps and Sgt. Ivy Baldwin with his quirky hot-air balloon, an innovation that would soon be used in the Spanish-American War. By 1908, a total of 340 acres were added to Fort Logan. In the photograph below, troops gather their rifles, canteens, and bedrolls with Loretto Heights College in the distance. (Above, AC; below, DPL WHC.)

THE DOMAIN OF BISON NO MORE, JULY 22, 1903. When Loretto Heights Academy officially opened in November 1891 as a girls' boarding school, it was far away from downtown Denver and far from its home institution, St. Mary's Academy. The Catholic sisters, under the direction of Mother Pancratia Bonfils, selected this beautiful site after having "tramped around . . . their view unbroken for several miles by any habitation of man, except by Fort Logan, which lay to the southwest," according to the book *Loretto in the Rockies*. (DW.)

WHEN GIRLS COULD DRIVE, 1890. This photograph shows a sense of optimism as a mostly female audience gathers for an inspection of the work at hand. The young girls commanding the buggy are surrounded by the Sisters of Loretto and other prominent women of Denver, surely imbued with excitement and wonder as this symbol of educating girls for a future Denver rises before them. (RU.)

NELLIE STOCKBRIDGE PLAYS THE ZITHER, JUNE 16, 1892. The first exhibition of art and music for students included a formal ceremony to honor the first two graduates of the institution, Olive "Ollie" Fort and Katherine "Kate" Casey. They received prizes of a laurel crown and gold medal. While it is known that Fort gave the valedictory speech and played the mandolin and that Casey played the organ, Fort's identity in this photograph is lost to history. (RU.)

A BEACON ON THE PLAINS. Loretto Heights College was established on the campus in 1918 using the same Romanesque-style building, with the last high school boarders remaining until 1941. It still dominates the southwest skyline and contains six floors with 86 rooms. Clad in red sandstone, its iconic central tower rises 160 feet. The architect, Frank Edbrooke, also designed the well-known Brown Palace Hotel and Central Presbyterian Church in downtown Denver. (DPL WHC.)

PLANNING FOR THE FUTURE, MAY 9, 1915. The enormous Marston Reservoir, southwest of Loretto Heights, was first conceived of in 1889. The Denver Union Water Company eventually operated the natural basin that had been enlarged to store and treat water and pipe it 10 miles to the city of Denver. Ever expanding and improving, the reservoir covered one square mile by 1899 and had a capacity of eight billion gallons of water. (DW.)

MEN ON MARSTON, MAY 26, 1915. Providing a reliable supply of water is no small feat and often goes unrecognized in the modern day. In this photograph, a diver is utilized to enter Marston to "remove cover from top of outlet pipe leading to north tower." Marston was eventually annexed into Denver in two pieces during February and March 1970. The lake is now one of three major treatment plants in the Denver Water system. (DW.)

Joe Fassett Had a Farm. Elsewhere on the plains southwest of Denver, homesteaders had continued to snap up claims on rich farmland, including pioneer and former miner Joseph W. Fassett and his 160-acre estate overlooking the Platte River north of Alameda Avenue. His property became part of the new town of Valverde, which incorporated in 1888 after having been platted earlier by Ed Reser along the new Denver and South Park Railroad. Locals anglicized the name with the pronunciation "Val-verd." (DPL WHC.)

West toward Valverde, c. 1915. A quiet Alameda Avenue speaks to a time before traffic jams. Down the middle of the road runs the Denver Tramway track. After Valverde's annexation to Denver in 1902, the city wasted no time in building infrastructure that would connect its far-flung southwestern neighborhood to town. The nearby Alameda underpass was built in 1909 to connect to Valverde's main street. (HC.)

DENVER TRAMWAY, c. 1915. The city and county of Denver separated what was urban from what was completely rural. Valverde was a bit of both, but since it was now part of the city, it received more attention with a streetcar connection. *Denver Municipal Facts* notes: "A fifteen-minute ride from the Champa street loop [downtown] on a Cherokee car carries one into the heart of Valverde." (HC.)

VALVERDE AND THE CELERY INDUSTRY, OCTOBER 11, 1913. So fertile were the green valleys of Valverde, it became synonymous with epic hauls of produce each year, especially with its prized celery. In this image, taken from South Navajo Street with a view looking east along Center Avenue, trees dominate the landscape along the South Platte River. The former town, which straddled Alameda Avenue, was full of such farms and greenhouses for many years. (*Denver Municipal Facts.*)

VALVERDE SCHOOL BALL TEAM, c. 1913. C.J. Allen (first row at left) and his teammates sit on the steps of the Valverde School, which opened its doors in 1890. The school sat on a high hill just a block south on Navajo Street from Center Avenue, overlooking the celery fields. Of the boys, *Denver Municipal Facts* reports that the "Valverde ball nine have cleared a portion of [this] ground and have . . . fought and won some hotly contested games." (AC.)

"WHERE THE COLUMBINES GROW," 1915. Colorado's first official state song was written by the principal of Valverde School, Arthur J. Fynn. Its haunting melodies include the lyrics, "The bison is gone from the upland, the deer from the canyon has fled, the home of the wolf is deserted, the antelope moans for its dead, the war whoop re-echoes no longer, the Indian's only a name, and the nymphs of the grove in their loneliness rove, but the columbine blooms just the same." (DPS.)

THE ALLEN FAMILY, C. 1917. Rose Hall Allen and Edwin Allen left Sioux City, Iowa, to join Rose's parents, Alfred and Sarah Hall, in Denver around 1888. Pictured around Rose and Edwin are their children, from left to right, (first row) Warren "Peter," Hazel, Perry "Bill," and Darlene; (second row) Helen, Ed, Harvey, Mabel, and Claude James "C.J." As the large family continued to grow, they settled on the southwestern side of town at 1153 South Lipan Street, just within the city limits of Denver. Edwin Allen operated the horse car tram, and his family initially grew crops for sale in town and raised chickens in an area dominated by truck farms and growing factories. To the north sat landowner Nathaniel K. Huston's lake. To the west were rolling prairie and the mountains. To the south rose the so-called Inspiration Hill, known as Ruby Hill today. According to *Denver Municipal Facts*, "the view from the top of this hill, day or night, is not only an inspiration, but an education. Beautiful Denver is seen from this hill in a manner not to be outdone by the view from many other attractive high points." (AC.)

Three
THEY HAD DIRT UNDER THEIR FINGERNAILS

THE HALLS OF DENVER, C. 1905. Sarah Ann Duffield and Alfred J. Hall sit with their children; they are, from left to right, (first row) Rose L. Allen and L. Grace Guth; (second row) Ida M. Shea, Fred H. Hall, Margarite I. Thompson, and Alfred J. Hall Jr. On December 1, 1926, the Halls celebrated 62 years of marriage. A grainy wedding photograph in the *Denver Post* a few days prior shows them in 1864, when both were 20 years old. (AC.)

IDA MAY HALL, C. 1895. A Denver pioneer, Ida Hall Shea, who was born in a sod house in Lodi, Dakota Territory, in 1875, later recalled, "After a prairie fire, mother gathered prairie chicken eggs in a tub." Arriving in Denver in 1887, the Hall family eventually settled on a street at what would become 1309 South Huron Street in an area called Manchester. This growing industrial neighborhood was annexed by Denver in 1901. (AC.)

FOUR GENERATIONS, C. 1927. Sarah and Alfred Hall sit in their yard with their daughter Rose, granddaughter Helen Allen Williamson, and great-granddaughter Betty Williamson. Betty is on Alfred's knee, and Rose (left) and Helen are in the second row. Nearby, the South Platte River flows. Along with Rose, two of Alfred and Sarah's other daughters also lived in the neighborhood: Margarite was next door at 1301 South Huron Street, and Grace was at 1246 South Kalamath Street. (AC.)

MANUFACTURING IN SOUTH DENVER. Near the Hall home at 1000 West Louisiana Avenue arose James Platt's paper mill in 1891. The large plant cost $357,000 and was, for some time, the only such mill between the Midwest and California. Utilizing the adjacent rail link and water from the river, the large structure became a beacon for employment opportunities. By the 1920s, the building remained but was known as the Continental Paper Products Company. (Jim Peiker.)

COLUMBINE MILK LABELS AND MORE. Rose's husband, Edwin Allen, spent 21 years of his life working at this paper mill. When he passed away in 1936, his obituary shed light on his earlier career prior to the introduction of electricity: "He operated the colorful horse car line from Orchard Place to Cherrelyn on which the horse rode downhill on the rear of the tram. He also ran the line from Orchard Place to Fort Logan." (Jim Peiker.)

29

MISERIES OF MILL SLAVES UNCOVERED. To the south in the Breenlow Park subdivision, more factories, such as a woolen mill, wheelworks, and cotton mill, were set up. Almost from the day it opened in 1891, the Overland Cotton Mill was accused of worker exploitation and child labor, paying children about 50¢ for 12 hours of work by 1901. In later years, the empty building became a notorious hangout for members of the Ku Klux Klan. (DPL WHC.)

GRIFFIN WHEEL COMPANY, OCTOBER 16, 1906. Located next to the Overland Cotton Mill, Griffin provided much better housing and working conditions for its employees. The cotton mill workers lived in "Misery Hollow," in reference to the deplorable living conditions for those employees, but some Griffin staff had brick homes, seen here facing Evans Avenue at South Osage Street. In this photograph, an empty Ruby Hill is seen to the north. Today, only the old cotton mill building remains standing. (DPL WHC.)

A NEW CENTURY HAS DAWNED. When C.J. Allen (right) was born in 1897, little could his parents, Rose and Edwin, have realized the revolution in movement that was about to hit the United States. By 1908, Henry Ford's Model T was introduced and was selling to the masses for $825 per car the following year. By 1923, C.J. was working for the Ford Motor Company in south Denver at the plant near Broadway and Tennessee Avenue. The man at left is unidentified. (AC.)

BROADCASTING CAR NO. 2. It can take years for people to adopt new ways of doing things. As a young person himself, C.J. Allen was skilled with horses but ecstatic to get behind the wheel of his own. Ford had a head start over other companies by making cars affordable for the average person. Allen would drive this lead vehicle with a caravan of new Fords behind him to southern Colorado and New Mexico to drum up new business. (AC.)

FORD MOTOR COMPANY, C. 1925. The large manufacturing plant opened in 1913 to assemble the popular Model T using Ford's revolutionary mass-production system. Numerous employees lived nearby in south Denver and also to the west near Overland Park and Manchester, including C.J. Allen. By 1923, the facility was turning out 150 cars a day for the western market. The price of a Ford auto had fallen to $364, with over two million cars being built across Ford's numerous

production facilities. According to the Ford Motor Company website, "In 1914, Ford with 13,000 employees produced about 300,000 cars, while 299 other companies with 66,350 employees produced about 280,000 vehicles." Adjacent to Ford's plant was the Colorado Tire and Leather Company, which began assembling sturdy rubber tires in 1919. Changing its name to Gates Rubber Company soon thereafter, it became one of Denver's largest manufacturing plants for much of the 20th century. (AC.)

A Day at the Races. C.J. Allen had received his automotive certificate from the Sweeney Automotive School in Kansas City in January 1918. Following a short stint in the Army in anticipation of fighting in World War I, Allen returned to Denver and resumed his passion with the automobile. Across the river from his home, the popular Overland Park had long ago shed its country club image and held races of all kinds—especially car races, which Allen participated in during the early 1920s. (AC.)

Colorado's First Flight, February 1910. Overland Park was not just a place for horse racing and auto competition. The state's very first airplane was observed overhead when French daredevil pilot Louis Paulhan (in scarf) wowed 10,000 Denverites as they gathered to watch his Farman airplane in the sky. During 1910, Paulhan was the first aviator to fly an airplane in numerous states. (DPL WHC.)

Amick's Drugstore, 1402 South Broadway. When Grace Small moved to Denver in 1917, she worked downtown for the Denver Drygoods Company and boarded at the home of Grace Guth at 1246 South Kalamath Street. Small eventually moved into an upstairs apartment above Amick's. She worked downstairs, learning to fill prescriptions from Frank Amick. This was a much easier commute than riding the streetcar down Broadway to reach downtown. (AC.)

C.J. Allen Strikes a Pose. When young men grow up, it is time for the long pants. The styles of the early 1900s are evident in this Dapper Dan, complete with the popular flat cap and a clip watch at his belt. Denver offered many possibilities for a fellow coming into his own, dressed to meet the day—the knickerbockers of boyhood left behind. (AC.)

WHEN BOY MEETS GIRL. Stopping in to purchase items at the drugstore near his house, C.J. Allen became quite smitten with Grace Small. In this photograph, they are standing on top of the building adjacent to Amick's, next to the apartment window where Grace lived. Grace had moved to Denver from Missouri to combat her hay fever and weak lungs. She dated Allen during the early 1920s and married him on June 18, 1923. (AC.)

GRACE ENCOUNTERS THE RHODE ISLAND RED. During their courtship, Grace would visit the Allen home at 1153 South Lipan Street. Like C.J., she came from a large farming family of six sisters and two brothers, so she fit right in. She also discovered that the person she had been boarding with upon her arrival to Denver was none other than C.J.'s aunt Grace. Denver was still a small town indeed. (AC.)

ALFRED HALL AND HIS GREAT-GRANDDAUGHTERS, C. 1934. Standing with his grandson C.J.'s daughters, Juanita Fern "Wanda" (left) and Viola "Elaine" Allen, the elder Alfred Hall, born in England in 1844, reflects on his long life. With his wife, Sarah, and a pioneer's fortitude that included bringing his family to Colorado, Hall witnessed the city of Denver grow into the 25th-largest city in the United States. (AC.)

FORT LOGAN HORSECAR, C. 1910. The girls' grandfather Edwin Allen operated the Fort Logan horse car line for many years. The tram ran a spur line over to the fort and circled back to Englewood. During the 1920s, a spur of the Denver & Rio Grande Western Railroad operated four daily trains to Fort Logan, and there were two trains daily on the Morrison Branch of the Colorado & Southern Railroad, located one quarter mile away. (DPL WHC.)

ONE CAN ALWAYS WALK. Streetcars pulled by horses once connected the farthest-flung parts of the city—mobility that enabled work and play to be accomplished. A man stands on the Platte River bridge with the Fort Logan tram tracks behind him. In the far distance, a woman walks on the road connecting to Fort Logan. Whether in 1910 or today, anyone who misses the horsecar or the bus has to walk. (HC.)

MOUNTAIN VIEW HOTEL AND RESTAURANT. As with almost all American cities, streetcar and train travel began a steep decline in usage after about 1925. In this photograph, bus transportation idles near the gates of Fort Logan and D.B. Wilson's Service Station is open for customers. The beautiful hotel, later lost to a fire, is attributed to the northeast corner of Lowell Boulevard and Mansfield Avenue, adjacent to the train tracks. (Friends of Historic Fort Logan.)

TOWN OF SHERIDAN AND FORT LOGAN, APRIL 2, 1915. In a view looking south from Loretto Heights, the tiny town of Sheridan intermingles with the fort. Sheridan's main street for many years and the main road into the fort was Lowell Boulevard, seen here in the middle of the photograph. In 1910, only about 500 people lived in Sheridan, with another 3,000 in nearby Englewood, the largest town in Arapahoe County after its divorce from Denver in 1902. (DW.)

SHIRLEY FARM DAIRY, C. 1925. This large farming operation, owned by Col. David C. Dodge, provided dairy products to his Shirley Hotel at Seventeenth Avenue and Lincoln Street in downtown Denver. That hotel opened in 1903 and soon joined forces with an adjacent hotel to form the Shirley-Savoy. The complex was especially popular with cattlemen each January during the National Western Stock Show. Prior to refrigeration, reputable hotels had fresh dairy delivered daily and shunned serving any bitter butter. (DPL WHC.)

MULLEN HOME FOR BOYS, 1933. Flour king John K. Mullen and his wife, Catherine, were tremendous philanthropists in Denver. They wished to provide a group home for wayward boys. After the death of his wife, Mullen worked with the De La Salle Christian Brothers of New Orleans–Santa Fe Province to establish such a school. In January 1932, the Mullen Foundation purchased the 420-acre Shirley Farm that was situated on either side of Bear Creek. (DLSI.)

EMPATHY, COMPASSION, MERCY, HOPE, AND WORTH. By 1934, a total of 50 boys were out of area orphanages and living at Mullen. Officially called the J.K. Mullen Home for Boys, it improved the buildings on-site at 3601 South Lowell Boulevard just north of Fort Logan. Mullen left an extensive charitable organization to support the school that outlived him. Of particular fondness for the boys were their participation in 4-H and the raising of championship horses. (DLSI.)

BROTHER LUCIEN CREATES A GROTTO. On the north side of the campus, a natural stone formation was utilized to make the Mullen Home Grotto of Our Lady of Lourdes. Lined with cement and electric lights, it included a statue of the Virgin Mary and one of Bernadette. On April 28, 1935, Archbishop Urban Vehr was joined by the boys of Mullen, the girls of Loretto Heights, and other Catholics of Denver to dedicate the shrine. (DLSI.)

THIS BOY IS READY FOR ACTION. The Mullen Foundation continued to purchase adjacent lands to enlarge the working farm, including the 480-acre Wolcott Farm in 1936. The boys worked with experienced farmhands and the Christian Brothers to operate the dairy, which also produced alfalfa, wheat, barley, and corn. Expanding on the buildings already at the Shirley Farm, by the early 1940s, the campus included classrooms, a chapel, dormitories, and a gymnasium. (DLSI.)

WHEN FEDERAL WAS SIMPLY "THE BOULEVARD." Boulevard Gardens developed on a portion of Rufus Clark's ranch, located south of Yale Avenue, around 1925. The full ad proclaims the virtues of building one's own home on land that could also produce crops for sale in the city. Other pages of the ad read: "Large half-acre tracts, beautifully located, wonderful view. Be independent . . . you can keep chickens and a cow." Jabez Vandeventer had farmed the land as early as 1870. (DPL WHC.)

RESTRICTED TO WHITES, JUNE 30, 1940. Further north, Evans Park Estates also offered large garden lots. Only folks of a certain background need apply, however, by taking the streetcar down Broadway and walking 30 blocks from there. The subdivision plat maps were often hand drawn and did not always follow the township and range system when placing streets. Arapahoe County did not correct these anomalies, resulting in streets in this part of town rarely aligning with adjacent subdivisions. (DP.)

42

THE NEW BOULEVARD SCHOOL, 1939. Between Evans Park Estates and Boulevard Gardens, the similar Southlawn Gardens subdivision developed. A new elementary school was built using federal PWA (Public Works Administration) funds. Taking the name College View School, it stood on the southeast corner of West College Avenue and South Decatur Street. With very few homes in the rural area, the nearby Loretto Heights College dominated the view from the school, making the new name an easy choice. (AC.)

WHEN CUSTOMS WERE DIFFERENT. School District 13 served this section of Arapahoe County north of Fort Logan and south of Garden Home. The land had been set aside in 1929 for school purposes. College View's first principal was E.A. Winters. The College View Eagles, numbering 341 pupils, chose green and gold as their first school colors. An active PTA was advertising this lineup for January 14, 1944, which included a "negro minstrel" program put on by the fathers. (AC.)

THE BLACK AND WHITE RANCH, c. 1927. North of Loretto Heights and west of Lowell Boulevard near College View stood the home of Wilberforce and Elfrida Whiteman. They are shown here with their grandson Paul Whiteman Jr. Wilberforce was the longtime director of music for Denver Public Schools. The land was purchased for them by their son, jazz king Paul Whiteman, as a retirement gift. The Whitemans designed the Dutch Colonial homestead, which stood officially at 2200 South Sheridan Boulevard in Arapahoe County. (HC.)

COWBOY OR CONDUCTOR? Paul Whiteman would often visit his parents on their 160-acre ranch, complete with a 13-acre lake. An adept farmer and rancher on his own estate in Pennsylvania, Whiteman would dress the part and then some when in town. He marveled at their beautiful gardens and menagerie of animals, including two Siamese cats, Si and Am, gifts from him via Paris who produced lots and lots of kittens. (HC.)

THE "KING OF JAZZ" WAS FROM DENVER. Paul Whiteman revolutionized mainstream American acceptance of jazz music as an art form and brought the genre to the forefront of popular culture during the 1920s and 1930s, conducting his well-known band. Married four times, including to Margaret Livingston at the Black and White Ranch in 1931, he would later return to Denver to dedicate an elementary school honoring his father in 1956. (Alfred Music, QC160418-2002.)

A PLACE CALLED GARDEN HOME. Organized in 1903, Garden Home School started out in a private home. In 1906, a schoolhouse was built on 10 lots that were purchased for $150. Into the 1940s, strong support from residents in this semirural farming community for their school included its name, which was also all over town, including the grocery store across the street from the school at South Lowell Boulevard and West Kentucky Avenue. (MTC.)

45

GEORGE AND BETSY HARRIMAN, NOVEMBER 11, 1901. A golden wedding anniversary photograph shows pioneer George "G.W." Harriman and his wife, Betsy. Instrumental in opening an early storage reservoir for agriculture in Jefferson County in 1873, Harriman changed the fortunes of the farmers that followed. Harriman Lake was part of his 850-acre ranch that was located along Bear Creek west of Fort Logan. (DPL WHC.)

HARRIMAN RANCH, C. 1900. G.W. Harriman's development of an extensive irrigation system on the dry plains southwest of Denver would prove invaluable not only to farmers and ranchers, but also later to the Denver Water Board, which would ultimately control the lake. His Harriman Lake and ranch, located south of West Quincy Avenue, along with the adjacent Fehringer Ranch, was annexed to Denver in five separate pieces beginning in March 1973. (DW.)

GRANT RANCH, C. 1949. Mary Belle and Ned Grant (right) gather the family for a picnic in front of their modern 1940 farmhouse. The enormous Grant Ranch had its origins in the late 19th century with former governor James Benton Grant, who amassed the acreage near what would become South Wadsworth Boulevard and West Bowles Avenue. The ranch became a prized agricultural showpiece, raising milk cows and hogs, and growing numerous crops. (GFP.)

NED GRANT AND THE GRANT "C" RESERVOIR, C. 1939. At its height, the Grant Ranch covered about 2,300 acres. Controlling many irrigation reservoirs south of Marston Lake, Ned Grant operated a large dairy operation that sold products locally. Grant was also involved with the creation of the nearby Centennial Race Track. The ranch itself would later become ground zero for the last annexation made by Denver in late 1973 and the bitter fight that ensued with Jefferson County. (GFP.)

FREDERICK O. VAILLE'S RANCH, FEBRUARY 22, 1915. In this view looking south toward the north berm of Marston Lake, the Vaille Ranch would eventually become the site of the Pinehurst Country Club. Vaille ran Denver's very first telephone company. His large two-story log house, built in 1911 and situated at 3999 South Sheridan Boulevard, was remodeled by Denver architect Temple Buell in 1939. The home is among the oldest in southwest Denver and remains standing in the Pinehurst Estates neighborhood. (DW.)

NORTH ON SHERIDAN BOULEVARD FROM BEAR CREEK, FEBRUARY 18, 1915. This lonely country road would one day see the Bear Valley subdivision on the west side with the Bear Valley Mall on the right and the huge Harvey Park subdivision developing to the northeast. Thoughts of the big city ever reaching this rural area must have seemed remote to the Denver Water workers that are improving connections to Marston Lake. (DW.)

NORTH ON IRVING STREET FROM JEWELL AVENUE, APRIL 29, 1915. Digging into the right-of-way across remote sections of Arapahoe County ranchland, workers excavate a trench on the enormous 700-acre H.C. Davis Ranch, which would be annexed to Denver on December 20, 1944, along with his Clarefield Mansion. The land on the right eventually housed the brand-new Anna Louise Johnson Elementary School, built for the burgeoning Burns Brentwood subdivision. It opened in 1952 after 1,200 new families demanded a school. (DW.)

WEST ON JEWELL AVENUE AT SOUTH FEDERAL BOULEVARD, MAY 9, 1915. Denver Water's infrastructure investments in the early 20th century are impressive. They were poised for growth. On the left side of this photograph, one of Denver's first McDonald's restaurants would rise in 1959. Jewell Avenue delineates the official boundary between the Harvey Park and Mar Lee neighborhoods. (DW.)

SOUTH FROM JEWELL AVENUE AT SOUTH FEDERAL BOULEVARD, MAY 9, 1915. Loretto Heights rises in the distance. The land in the foreground eventually became the site of the 320-acre Burns Brentwood subdivision and the Brentwood Shopping Center. It was annexed to Denver on May 9, 1946, in part to receive reliable water service. Mar Lee covered 360 acres and was annexed November 30, 1946. (DW.)

NORTH ON FEDERAL BOULEVARD FROM ARKANSAS AVENUE, APRIL 21, 1939. In this image, a bulldozer and road grader improve Federal Boulevard. The farmhouse on the right eventually gave way to a large retail center that included a Safeway store, with an Albertson's and Mr. Steak built across the street. This occurred following a giant 620-acre annexation called "the Island," which took place on April 16, 1948—Denver had completely surrounded this area due to earlier annexations. (DW.)

Four

FARMLAND NO MORE

1147 WEST MISSISSIPPI AVENUE, NOVEMBER 6, 1931. These orphaned children from the Tuckaway Home were seeking donations as the storm clouds of the Great Depression were in full form. According to the *Denver Post*, "Twenty-five youngsters are cared for by two women who find happiness in managing the place." Eventually relocating to the old Fassett Farmhouse at 50 South Alcott Street, this orphanage sat at the edge of Valverde farmland that would eventually become the Athmar Park subdivision. (DP.)

51

Rose Hall Allen, Easter 1947. Standing by her namesake, the widow Rose Hall Allen remained at the family home located down the street from Tuckaway until her death on January 11, 1955. Her pioneer homestead, where she finished raising nine children, remained standing for most of the 20th century in an area that became increasingly full of warehouses and light industrial facilities. To the west, farm fields were giving way to subdivisions. (AC.)

Denver Fire Station No. 19, at 1401 West Alameda Avenue, c. 1925. Opening in 1915, the firehouse joined other new buildings on Alameda Avenue, including the Valverde Neighborhood House, two doors down, which opened in 1921. Residents lamented the loss of their huge 150-year-old cottonwood near South Tejon Street, which was deemed a traffic hazard in 1923. Next to it, a new Valverde School opened the same year, replacing its 1890 predecessor. (DPL WHC.)

VALVERDE POST OFFICE NO. 19, C. 1930. This photograph is ascribed to Denver's prolific photographer Charles Lillybridge, who lived nearby along the South Platte River. Although the exact location of the post office cannot be pinpointed, its numeric attribution relates to the post office's development of the zip code system in the 1960s, when a large portion of southwest Denver was assigned zip code 80219. (HC.)

VALVERDE SERVICE STATION, 1940. The South Platte River would sometimes flood. Folks gather by "Everett's Station" to survey the rising river. While old-timers were used to Valverde's streetcar service, it was quickly being supplanted by the automobile. The density of shops along West Alameda Avenue was changing dramatically as more automobile-oriented businesses, requiring parking spaces, replaced the walkable storefronts that were part of the original town of Valverde. (PHS.)

STARTENA SOLD HERE, 1201 WEST ALAMEDA AVENUE, C. 1945. Anita walks from the feedstore in her jodhpurs. Among the numerous businesses that lined Alameda Avenue, this one illustrates the semirural character that was still prevalent in Valverde up through World War II. Next door, the Quality Market, with a large walk-up storefront, peddled fruits and vegetables and other groceries out of a converted 19th-century house. (HC.)

GOOD SHEPHERD LUTHERAN CHURCH, 770 SOUTH FEDERAL BOULEVARD, C. 1947. Church members gather for the ground breaking of their new building. Aside from two previous airport land annexations, the first large annexation Denver undertook since 1902 was the addition of Mountain View Park on December 29, 1943, with 240 acres of land that would include Good Shepherd's parcel. Denver was looking to grow southwest and southeast as the war years were coming to a close. (GSLC.)

720 South Bryant Street, August 3, 1947. Parishioners gather for the Good Shepherd Lutheran Church charter signing ceremony. Though these children did not know it, the postwar baby boom was underway. Soon, area schools were inundated with students, and the Denver Public Schools began a massive 25-year building campaign. Built in 1951 at 1050 South Zuni Street, the Owen J. Goldrick School, named for Denver's first teacher, was the first of these schools to open in southwest Denver. (GSLC.)

Perry School (1911), First Avenue and Perry Street, June 1952. Ellen Daugherty (second row, second from left), who resided at South Decatur Street and West Florida Avenue, would be bused to "old" southwest Denver for part of her schooling due to overcrowding. This meant a ride to the Barnum neighborhood, north of Alameda—an area that had been annexed to Denver in two pieces between 1896 and 1901. Her teachers included L. Keeler (left) and Robert Price (right). (Ellen Daugherty McMichael.)

DENVER'S DIRTY TRICKS! With the annexation of Mountain View Park, the community of Garden Home was on edge. Seeking to set its own course, it incorporated as the town of Westwood on April 27, 1944. It found itself surrounded by Denver, however, later that year with the city's annexation of the Davis Ranch to the south. By spring, there was a growing and heated debate in Westwood on the benefits of joining Denver or staying independent. (MTC.)

WHEN WESTWOOD HAD WON. With its rural telephone exchanges still evident, Westwood wanted to assure residents that it was a viable town. Like other areas of rural Arapahoe County, Westwood had seen rapid but unplanned and unregulated development during the Depression when building lots were sold for $1 down and 50¢ a week. About 8,000 residents were living in Westwood when Denver began its campaign to annex the town. (MTC.)

THE GARDEN HOME BLUE JAYS WITH COACH FRED SMITH, 1942. During World War II, the nearby Denver Ordnance Plant opened up and Westwood became a prime spot for new houses to be built. The growth was so fast and furious within Arapahoe County that any thought of community planning was nearly nonexistent. In 1945, federal dollars helped expand the Westwood campus and also built two additional grade school facilities, Irving and Belmont, for which the cash-strapped district was grateful. (MTC.)

SENATOR JOHNSON BRINGS HOME THE BACON. Ongoing court battles among residents, Denver, and Arapahoe County during this time were vicious. Finally, on February 18, 1948, the City and County of Denver officially recorded the annexation of the town of Westwood. According to principal Wilford Woody, "Despite the animosity that had been built up during the annexation fight and prior to that time, it has been possible . . . to unite the several civic, religious, educational and welfare organizations [to form] the Westwood Service Association." (MTC.)

57

AEROPLANE BAR AND GRILL, 3310 WEST ALAMEDA AVENUE. Inspired by Charles Lindbergh's 1927 flight, the well-known Aeroplane Bar & Grill contained a huge dance floor and claimed to have the longest barroom in Colorado. The Aeroplane joined other businesses along Alameda Avenue during the mid-20th century, including the Alameda Farm Dairy, Alameda Live Poultry, Bernie and Evelyn's Drive-In, Rose's Beauty Shop, Alameda Shoe Shop, Ben Franklin 5 & 10, Busy Bee Service Station, and Elwood Edwards Used Cars. (AC.)

THE SAINT'S TROPICS NIGHTCLUB, 4842 MORRISON ROAD. Warren St. Thomas ran his burlesque nightclub on the highway out of Denver during the 1940s and 1950s. The Mid-Century-designed wonder included dramatic indirect lighting with interior tropical forest theme and an "alligator pit." In this particular photograph, Evelyn "$50,000 Treasure Chest" West's appearance is advertised. The club attracted folks of all types. Inside, the cocktail waitresses were known to wear faux leopard skin outfits. (DPL WHC.)

SUE ATKINS, COLLEGE VIEW SCHOOL, 2680 SOUTH DECATUR STREET. Beginning a teaching job in fall 1952, Ursula "Sue" Atkins dedicated her 36-year career to the children of College View. Reflecting on College View after retiring, she recalled, "I just liked the neighborhood . . . the people were more like what I'd grown up with. It was rural . . . they had chickens and horses. Even when they annexed into Denver they had those things. Such a close bond in people in that neighborhood." (AC.)

SUE ATKINS WITH HALLOWEEN SECOND GRADERS, C. 1955. Like Westwood, College View was the name of both the school and the neighborhood. It also had a robust retail zone along Decatur Street that was intermixed with area homes and catered to residents. Children especially enjoyed buying red licorice, wax lips, and candy cigarettes at such places as Pinkie's Drugstore on Yale Avenue. Up the street was Harvard Liquors, and next to it was an animal feedstore. (AC.)

2743 South Hazel Court. New developments were cropping up across South Federal Boulevard from College View, including this home built by the C.C. Ford Company. Christopher Erskine purchased it for $12,100 on December 5, 1952. The new house had three bedrooms with no basement and no landscaping. The postwar housing boom was well on its way, as many young couples with small children and growing families began to move southwest. (Christopher Erskine.)

Franklin Burns, the William Levitt of Denver. With home-building experience dating back to 1899, the Burns family was primed to truly take advantage of evolving federal housing policy, standardized design, and liberal financing options to build their massive subdivision at Brentwood between 1946 and 1952. In this ad, a new West Evans Avenue is on the left side with South Federal Boulevard at the bottom. (D.C. Burns Realty and Trust Company.)

SOUTH GREEN COURT, C. 1951. The Burns Brentwood subdivision covered 320 acres of the former Clayton/Selander farm, bounded on the north by Jewell Avenue and on the east by Federal Boulevard and stretching eight blocks south to Yale Avenue and six blocks west to Lowell Boulevard. These single-story ranch homes were built primarily for returning veterans and were some of the first to forgo the use of brick in their construction in Denver. (MFC.)

ANTHONY MULLIGAN WITH DAUGHTER KAREN, C. 1952. A ship medic during World War II, Anthony Mulligan came to Denver hoping to cure his asthma. In 1950, he met Trudy Gabriel. After moving to their brand-new Brentwood home at 2650 South Green Court, they eventually raised seven kids there. Up the street stood All Saints Catholic Church. In 1955, the new Katherine Gust School opened to serve their growing family. (MFC.)

ETHEL GABRIEL PUSHES COLLEEN AS KAREN WALKS, C. 1952. The Mulligan family home is in the middle of the photograph. By 1949, Burns had completed 500 homes across Denver—the most built ever in Colorado in one year at that time. Mass-produced housing had arrived. For the Mulligan family, planting grass and landscaping was key to differentiating their house from the neighbors'. Still, it took years for each of these nearly identical houses to stand out on its own. (MFC.)

KAREN (LEFT), PAM (CENTER), AND COLLEEN MULLIGAN, FEBRUARY 1958. With Federal Boulevard in the background, residents of Brentwood could hear the roosters of College View making their ruckus just across the street. The girls were more interested in thinking about summer when their small concrete pool, built by their father, would be ready for swimming. Winter use meant ice-skating. Their trash incinerator sits in the corner of the backyard. (MFC.)

ANTHONY MULLIGAN AND FAMILY, RUBY HILL, C. 1968. From left to right, Kevin, Sheryl, Tony, and Shaun stand at the crest, with the Overland Golf Course behind them. Once on the outskirts of town, the hill was used as a dump and as a site for KKK cross burnings. Denver purchased the 88-acre site in 1954 and implemented beautification plans after 1960. Loads of Brentwood kids remember the sledding at Ruby Hill fondly. (MFC.)

STELLA BARELA MARRIES MELVIN B. GARCIA, AUGUST 23, 1952. The old All Saints Church, which stood at West Vassar Avenue and South Federal Boulevard, was destroyed in a massive fire on January 8, 1953. It was situated in the Brentwood subdivision but across the street from Arapahoe County. Both Denver and College View fire personnel fought the blaze. After rebuilding, the congregation erected yet another structure in 1967 with a stunning 30-foot-high mosaic-glass and plaster mural facing Federal Boulevard. (Melvin G. Garcia.)

MELVIN B. GARCIA WITH JOE MIRANDA, 1944 SOUTH TEJON STREET, C. 1953. Melvin Garcia (left) worked down the street at Griffin Wheel. Stella Barela graduated from Scenic View School, which took its name from the view of Pikes Peak. Both knew each other from growing up in this rural area of self-built shacks south of Ruby Hill with outhouses and no indoor plumbing. As Denver pushed up against these areas, hysterical newspaper accounts began to trumpet all that was wrong with the neighborhood, pejoratively called "Goat Hill." (Melvin G. Garcia.)

PROUD RESIDENTS OF GOAT HILL, C. 1955. From left to right, Rebecca Gallegos, Eva Barela, unidentified, and Faustino Lucero stand near 1960 West Pacific Place. Pressure to improve the area was immense but what city would take this on? According to the *Rocky Mountain News*, "A girl . . . carrying a pail of water . . . boys at play in a rubble-filled lot, within a few feet of an outdoor privy which fouls the air . . . chickens, humans . . . offal in an undistinguishable mass . . . crime . . . you can't call it a community . . . nobody wants [it]." (Melvin G. Garcia.)

64

Five

Ranch Houses, Not Ranches

The End of an Era Begins. As the 1950s dawned, the pressure to develop on farm and ranch lands located farther from downtown Denver was immense. The automobile allowed for greater decentralization of resources, and subdivisions were springing up across the Denver region. Arthur "Tex" Harvey purchased the former 320-acre Whiteman estate from Frederick Bonfils in 1948. He added the 160-acre Lakeridge parcel in 1950 with plans to develop his new subdivision, Harvey Park. (DP.)

THE CHANGE CAME FAST, C. 1954. In this view looking east, the new Harvey Park subdivision is under construction among the irrigation reservoirs and agricultural ditches of Arapahoe County. Beyond sit College View and Scenic View with their noticeably different street pattern of large acre and half-acre farming plots. Denver annexed Harvey Park's 659 acres north of Yale Avenue (center road) on March 16, 1954, and another 594 acres south of Yale Avenue on February 15, 1955. (DP.)

UPSCALE SOUTHWEST, SEPTEMBER 9, 1955. While most homes within Harvey Park fit a typical brick ranch style and catered to the dominant middle class, there were a few enclaves carved out for bigger, custom-built homes, especially those that sat next to the irrigation reservoirs. Southwest Denver stands out as unique in the area in this regard, wherein these lakes are not accessible to the general public. Developer Lou Carey turned Ward Lake No. 5 into Riviera Circle Lake. (DP.)

CAREY'S HOLIDAY HOMES. Harvey Park was developed by numerous builders, including K.C. Ensor, the Frederics Brothers, Franklin Burns, Ted Hutchinson, and C.C. Ford. North of Riviera Circle Lake, Carey Realty Company built 200 contemporary houses, designating the first model home at 1905 South Utica Street. These two- and three-bedroom ranch houses consisted of 848 to 1,926 square feet. Nearby, K.C. Ensor included his new raised ranch "to fit into the rolling hills within the subdivision." (DP.)

HOLIDAY HOME, 2074 SOUTH UTICA STREET. The Carey and Ensor models were featured in the 1954 Parade of Homes. The development of these new subdivisions marked a strong rebuke of typical urban design. Alleys, porches, and detached sidewalks were replaced by larger yards, driveways, carports, or attached garages, as the automobile transformed new neighborhoods across the nation, including southwest Denver. (DPL WHC.)

67

THE YEARS OF THE HAPPY HOUSEWIFE. Federal policy instituted a set of universal building standards that already aligned with many urban areas but were often lacking once one left city limits. This evolution started during the 1920s but got a much-needed boost with the election of Franklin Roosevelt. The government recognized a need to offer future subdivisions a standard set of guidelines for lending purposes, especially with the establishment of the Federal Housing Administration. (DP.)

FRANKLIN BURNS TRANSFORMS DENVER. Both Franklin Burns and Ted Hutchinson dominated Denver's housing market during the 1950s. "Burns Better-Built Bungalows" were constructed across the city and numbered 7,000 by 1955. Burns fought against Denver's blue line that was instituted to prevent water going to areas outside of city limits. He worked tirelessly to get unincorporated areas annexed to Denver in order to receive this water, including Burns Brentwood. (D.C. Burns Realty and Trust Company.)

CLIFF MAY, THE FATHER OF THE MODERN RANCH. The Burns Company also built the innovative Cliff May homes in Harvey Park. The 170-house tract, southwest of Iliff Avenue and Lowell Boulevard, stood out owing to unique architectural features that included wide eaves, floor-to-ceiling windows, and distinctive landscape treatments. The homes were made popular through publications such as *Sunset* magazine, and buyers were intrigued by May's prefabrication process, which allowed for construction in as little as 30 days. (Cliff May Papers, University of California, Santa Barbara.)

BRENTWOOD SHOPPING CENTER, DECEMBER 29, 1961. The strip mall was a relatively new concept in the early 1950s, but it was born out of the necessity to provide ample parking for customers. Opening in 1952, Brentwood offered 200 parking spaces with an overflow lot behind the shops that could accommodate another 200 cars. "The center is located in one of the city's fastest growing sections," according to the *Southwest Denver Herald Dispatch*. (SWDHD.)

HUTCHINSON BUILDS 2,200 HOMES, HARVEY PARK SOUTH. Harvey Park continued to grow south of Yale Avenue and was on the lips of new homeowners across the city. Ted Hutchinson founded Hutchinson Homes in 1953, following the successful development of University Hills in southeast Denver. His other projects included portions of Mar Lee Manor to the north of Harvey Park. He was considered Denver's largest home builder by 1955, with a 350-man construction team. (DP.)

NORTH FROM SOUTH SHERIDAN AND BEAR CREEK, C. 1956. Trees at the top of the hill line the agricultural ditch that connected to Loretto Heights College to the east. Cows and corn bide their time. Prefabrication of materials was seen as the key ingredient to building more housing at a cheaper cost following the housing crunch after World War II. Plywood wall panels, steel roof trusses, and aluminum siding revolutionized the housing industry. Still, Harvey Park's well-built homes were constructed of brick. (DPS.)

MERLE AND VELMA HECKENDORN'S HOUSE, 2797 SOUTH PERRY STREET. The Heckendorns placed an option on their new Hutchinson home on November 19, 1955. The home was priced at $12,250. The lot was still part of the West Arapahoe Soil Conservation District and was assessed taxes in 1956. Restrictions on the property included that "no livestock, animals or poultry shall be raised, bred or kept on any lot"—also, no gas or oil drilling. (Lynda Heckendorn.)

SOUTH TOWARD BEAR CREEK AND FORT LOGAN, SPRING 1956. Postwar subdivision building applied principles that shunned the traditional street grid in favor of curvilinear street patterns. Neighborhoods were designed to connect via major arterials, but interior streets were to incorporate curved roadways and cul-de-sacs that further controlled traffic entering and exiting the neighborhood. Just to the south, a new four-lane highway, Hampden Avenue, was finished in 1962. (Lynda Heckendorn.)

HECK'S 66 SERVICE STATION, 4740 WEST COLFAX AVENUE, C. 1955. When Merle Heckendorn (right) moved to Denver, he managed this gas station and lived around the corner on Winona Court. But the pull of a new house in Harvey Park was too strong. Heckendorn chose to commute. He joined thousands of others in a now familiar ritual. His neighbors were often driving to other places of employment nearby, such as the Denver Federal Center or the Martin plant. (Lynda Heckendorn.)

A NEW TELEVISION, CHRISTMAS 1956. Merle and Velma's son Dale enjoys opening his presents, which include a toy service station, holster set with guns, chaps, and a vest. He would soon attend the brand-new Sabin School (1958), located at 3050 South Vrain Street, named for Mary and Florence Sabin. Mary was a longtime teacher in Denver, and her sister Florence was a pioneer for women in medicine and public health. (Lynda Heckendorn.)

DAVID A. AND DIANE WEIST, EASTER 1952. Back across South Federal, so-called hope homes, such as this one at 2715 West College Avenue, had been built during the 1930s and 1940s with the idea that an upstairs could be constructed at a later date. Neighboring houses indicate that each homeowner made an individual choice about what a home could be—the antithesis of the newly planned communities nearby. (AC.)

THE HOUSE THAT DAVID FRANKLIN WEIST BUILT. Returning from serving in the Navy in World War II, Weist had a can-do attitude that resulted in no task being too large. In 1956, he began construction on the upstairs of his hope home. He proudly holds his daughter Diane during a break in his work on the fulfillment of the family's hopes. Next to him is Ronald Mares along with the family's television antenna, a sure sign of prosperous times. (AC.)

NEW DENVERITES NEED POWER, C. 1952. The prairie landscape gives way to a new power plant near the former Overland Cotton Mill, with its "Cobusco" smokestack. The Colorado Builder's Supply Company had acquired the building in 1939. When the neighboring Arapahoe Power Plant was under construction in August 1948, crews began uncovering skeletons and discovered they were building on the burial ground for former workers at the Manchester mill. (AC.)

THE DAVIS RANCH NO MORE, C. 1951. Stephen "Steve" Snow stands in a field of flowers at 1790 South Decatur Street, with Federal Boulevard in the distance. His grandparents, immigrants from Italy, settled first in Logan County but eventually made their way to Denver during the Depression. Seeking a more rural setting, they moved southwest to buy a large parcel of land in the new Garden Park subdivision. (AC.)

Easter Portrait, 2571 West Wesley Avenue, c. 1952. Steve Snow (right) stands with his grandparents Ernest and Carmen Bordigan at his home in the College View neighborhood. With him are Ronald O'Neall and Elizabeth Aycock. In the distance, Loretto Heights College dominates the landscape. A visit to St. Patrick's Catholic Church in Fort Logan was on the agenda but would soon be replaced by visits to the newer and closer All Saints. (AC.)

Schmitt's School Colors Were Blue and White. In 1960, Steve Snow's mother, Violet, now a widow, was able to afford a brand-new home next to her mother Carmen. She chose to have a handsome black brick structure built at 1785 South Dale Court. Steve (second row, fourth from left) left all of his friends at College View to attend the new Jakob Schmitt School (1955) for half a year before starting at the new Harry Kepner Junior High (1953). (AC.)

75

THE REICHERT FAMILY, 1730 SOUTH DALE COURT, JUNE 1963. Steve Snow's neighbors down the street included twins Karen Sue (left) and Karla Mae, shown here with their mother, Ginger, and sister Janet. Ginger had grown up in downtown Denver, but like millions of Americans, she headed for the newly built suburbs following World War II. Suburbanization was perceived as more healthful and seen as an escape from crime and pollution in the older parts of cities. (Ginger Reichert.)

DENVER'S FINEST, DECEMBER 24, 1956. Ginger's husband, Glenn Reichert, worked as a Denver police officer. Steve Snow and his friends would take their chances to harass Glenn by siphoning gas from the tank of his police car. For the officer, the petty crime in the suburbs paled in comparison to the growing decay and urban social problems that were beginning to manifest themselves in older parts of Denver. (Ginger Reichert.)

1,200 SILVER DOLLARS
TO 48 LUCKY ATHMAR FAMILIES!

ABSOLUTELY NOTHING TO BUY!

Contest limited to adults only. You must present valid identification to claim a prize. Only one prize per person. You must be present at drawing.

You MUST Have Your COUPONS In By 6:45 Dec. 22 The Drawing Will Be At 7:00 By The Big Sign

VALUABLE COUPON
Athmar Merchants Giant Christmas Give-Away
$1,200 IN CASH PRIZES
Winners must have proper identification, and be present at Athmar, Friday, Dec. 22nd at 7:00 P.M. to win. Contest open to adults only. Athmar merchants, their employees, and relatives not eligible.

NAME
ADDRESS

48 WINNERS!

(1) $100.00 prize — $100.00
(4) $50.00 prizes — $200.00
(8) $25.00 prizes — $200.00
(35) $20.00 prizes — $700.00

Total $1,200.00

MERRY CHRISTMAS AND HAPPY NEW YEAR

FROM THE 16 MERCHANTS IN ATHMAR

REGISTER TODAY AT ANY OF THESE 16 ATHMAR MERCHANTS:

ATHMAR DAIRY
1929 W. Mississippi

ATHMAR Restaurant & Lounge
1795 W. Mississippi

BROWN'S LADIES' WEAR
1921 W. Mississippi

BROWNFIELD DONUTS
1781 W. Mississippi

Colo. Federal Savings and Loan
1925 W. Mississippi

A. G. EAKERS
1913 W. Mississippi

ATHMAR FLORAL SHOP
1931 W. Mississippi

ATHMAR LANES
1733 W. Mississippi

ATHMAR LAUNDROMAT
1727 W. Mississippi

ELLIS JEWELRY
1933 W. Mississippi

GAMBLES
1935 W. Mississippi

HESTED'S
1911 W. Mississippi

OWL REXALL DRUGS
1905 W. Mississippi

MILLER'S SUPERMARKET
1865 W. Mississippi

NEW FASHION CLEANERS
1927 W. Mississippi

THRIFT FINANCE CO.
1923 W. Mississippi

AN ANNUAL SILVER DOLLAR DRAWING, DECEMBER 22, 1961. The family sometimes shopped at the nearby Athmar Park Shopping Center. On the cold night of the contest, hundreds of families showed up for a chance to win $1,200 in cash prizes. Karen and Karla Reichert were present and helped with the drawing. While Brentwood had a Red Owl and King Soopers, Athmar Park had the Miller's Supermarket. (SWDHD.)

WHAT PRICE PROGRESS? Beginning in the 1930s, neighborhood children visited the privately run Progress Plunge swimming pool at the southwest corner of Florida Avenue and Irving Street. Fred and Elizabeth Jackson had been in Arapahoe County since 1912. They eventually bought 80 acres southwest of Federal Boulevard and Florida Avenue in 1926 and called it Progress Heights. They farmed part of the land, but their pool was what they were known for; it was a constant source of joy to all. (AC.)

SWIM

AT

PROGRESS PLUNGE

Your CHILD
is under constant supervision
Trained Life Guards on Duty
ALWAYS

Clean - refreshing - healthful
Take the Kiddies and Pack a Basket

PROGRESS PLUNGE

3300 West Florida Ave.
Westwood 386

J. K. MULLEN HIGH SCHOOL

FORT LOGAN, COLO.

Students accepted for all classes from all faiths.
Call or write at any time. Enrollment limited to 50 boys.
School bus available for Denver, and South and West of Denver.
Write J. K. Mullen High School, Fort Logan, Colo.—SU. 1-6909

A NEW NAME, SORT OF. By 1953, J.K. Mullen Home for Boys modified its name slightly to J.K. Mullen High School and opened up its enrollment to paying boys. As Denver continued to grow south and west, the school was at the borders of the city, though it still listed itself as being in an unincorporated community. That would change on August 7, 1961, when Denver would annex the 1,040-acre Fort Logan tract south of Bear Creek. (AC.)

THIS FIELD HAS A FUTURE, SEPTEMBER 9, 1955. Farther north, the baby boom generation was putting enormous pressure on Denver's public schools. The schools of the former city of Westwood were no longer big enough to meet the demand, so construction began on Warren Knapp School at 500 South Utica Street. Knapp had been a longtime principal of west Denver schools. Designed by architect Charles Gordon Lee, the new school welcomed 825 students in the fall of 1956. (DPS.)

Retail Follows Rooftops, December 22, 1961. Business was booming in Westwood as more urban services began to infiltrate this formerly rural community. As the population grew, the Westwood Theatre opened on the north side of Alameda Avenue at Irving Street. To the southwest on Morrison Road, the historic diagonal highway leading to the town of Morrison, the Alamor Merchants Association advertised Joe's Thrifty Liquors, Ricardo's Barber Shop, and the Carter House Restaurant. (SWDHD.)

Praying Hands Arise from the Fields. Throughout the areas that were newly annexed to Denver, businesses, schools and churches, as in any new community, were under construction. The exceptional Trinity Lutheran Church, at 4225 West Yale Avenue, features an A-frame design meant to mimic praying hands. Designed by architect Donald Combs, this Mid-Century wonder is similar to the nearby Christ the King Lutheran Church, also in Harvey Park at 2300 South Patton Court. (Trinity Lutheran Church.)

79

THE ALLEN PONDS AND FARMSTEAD, C. 1948. Although C.J. and Grace Allen did not know it at the time, their purchase of 80 acres of Jefferson County farmland around 1945, southwest of Simms Street and Belleview Avenue, sat in an area that would soon be on the doorstep of Denver's relentless annexations southwestward. The city's focus on the edge of town was a direct result of the massive population growth and relocation to new suburban locales. (AC.)

BILL AND THEDA ALLEN WITH DAVID A. WEIST, C. 1947. Who says a boy's best friend has to be his dog? As Bill and Theda look on in amusement, David romps with his fine feathered friend. For a child, a small farm can seem as big as the whole world, and the goose and other animals that called the farm home would have provided ample fascination and numerous playmates for any inquisitive child. (AC.)

David and Diane Weist with Trinket, c. 1954. C.J. and Grace Allen grew wheat and alfalfa and raised pigs, chickens, cows, and horses on their land. They enjoyed having their grandkids over to spend summers on the farm. In this photograph, Trinket is pulling the kids north on Simms toward Belleview. The Allens' neighbors to the east were the locally famous Beers sisters—Bessie, Mattie, Edna, Ollie, and Marguerite—who ran a very successful dairy operation. (AC.)

On the Farm with Grace Allen and Brother Alex Small, c. 1956. With the diffidence of maturity, Glasseyes sticks to horse business with no need to pose. Sockeye, however, shows the full ears-up gaze of a proud colt preening for a picture. Were these horses aware that they sat at a transition in time, when horsepower was being supplanted by machine power? No matter—Sockeye took his moment. (AC.)

HASZELBART BARN, SOUTH SIMMS STREET, C. 1959. Rural settings have always captured the imagination as places for wholesome air and healthy living. In Colorado, the traditional backdrop of sylvan glades was replaced with the vertical punctuation of the mountains, sometimes aloof, sometimes welcoming. Whatever the mood, Patricia Haszelbart's drawing stands as solid as the mountains. Sam, Patricia, Bart, Heidi, and Bill lived just south of the Allen farm. (AC.)

THE ERA ENDS. C.J. and Grace Allen sold their farm to Carl Edwards in 1961. Here, C.J. proudly poses with one of his farmyard friends. Perhaps the cow sensed its 15 minutes of fame was at hand, which explains the coquettish turn toward the camera. But make no mistake, rural farmland was put on notice; it was more valuable not for its fertile soil or open space, but for what it could become: new subdivisions. (AC.)

Six

Denver Grows Southwest

Elaine Allen Weist (left), College View Annexation Committee Secretary. During the 1950s, College View, Scenic View, and Loretto Heights sought annexation to Denver. Elaine is standing with her teammates from the Denver Women's Bowling Association, including Elaine Loechel (second from left). The busy men and women of College View found time to gather annexation petition signatures from their neighbors to deliver to city planner George Nez downtown. For many women, this new world of can-do civic activism was exhilarating. (AC.)

83

Office of the Mayor
City and County of Denver
CITY AND COUNTY BUILDING · DENVER 2, COLORADO

November 29, 1963

To The Residents of the College View Annexation Area:

As you probably have heard, the College View annexation to the City and County of Denver has been held to be invalid by the Arapahoe County Court. It was found that a majority of the resident landowners had signed the petition, and a majority of the privately owned land had been signed for, however when street areas were counted the signed land represented slightly less than a majority of the total land area of the territory proposed to be annexed.

Denver takes the position that street areas, which are ineligible to be signed for or against annexation by anyone, should not be counted in determining the area of an annexation. We have appealed the Arapahoe County Court decision to the Colorado Supreme Court.

The Arapahoe County Court has granted a stay of execution of the decision to January 2, 1964. You are thus to be treated as though you are residents of the City and County of Denver, and as such you will continue to receive municipal services and your children will continue to attend Denver schools.

Thank you for your patience and steadfastness. I regret very sincerely that you must continue to endure a period of uncertainty, and I hope that the outcome of this litigation will establish once and for all your status as Denver citizens.

Sincerely yours,

Thomas G. Currigan
MAYOR

TGC/pl

BUT THERE ARE MANY OBJECTIONS. In 1957, Englewood advanced its annexation of Scenic View. Ongoing court battles with Arapahoe County delayed the outright annexation of College View by Denver for years, but Loretto Heights' 148 acres were absorbed January 7, 1958. Mayor Thomas Currigan was a strong proponent of any annexation. He and his staff kept copious records that outlined the status of every single annexation battle that was occurring. At the same time, downtown Denver struggled to compete. (AC.)

WEIST HOME ON A DIRT ROAD. College View residents were fighting for typical urban services like those they saw across Federal Boulevard. A generation earlier, this would have been unthinkable in rural Arapahoe County. But postwar optimism and a growing middle class lobbied for access to the same basic services: street paving, sidewalks, city water instead of wells, sewage hookup instead of septic systems or outhouses, libraries, and modern electric and telephone service. (AC.)

CITY COUNCIL ELECTIONS, MAY 21, 1963. Women, as a whole, were beginning to flex their political muscle during the 1960s. Running in a five-way race for the seat for District 2, which was west of Federal Boulevard and south of Twelfth Avenue to the city limits, Estelle Fikany came in third place, with 25 percent of the vote. Until 1975, there were no women on the Denver City Council. (SWDHD.)

STRONG OPINIONS INDEED, MAY 2, 1963. Both the College View annexation and the council election were on the minds of readers of the *Southwest Denver Herald Dispatch*. Regarding electing a woman to city council, one reader claimed "[she] is not cut to a political pattern any more than a man is cut out to wear a frilly apron." The next opinion opines, "I have never seen an area that needs to be cleaned up more badly." (SWDHD.)

ORIE GREEN AND JUNE GRISSOM INTERVIEW, MAY 12, 1961. The problems in Arapahoe County were nothing new. Residents increasingly felt they were living on the wrong side of the tracks. There were ongoing efforts to clean up College View and Scenic View, but according to a *Denver Post* interview, "So far, not a single man in the community has offered to help." Green added that "rats play around in the sun like kittens," among other problems. (DP.)

SOUTHWEST DENVER'S PAPER. Covering all the news in southwest Denver and previously in the Barnum neighborhood since 1925, the Rosenberg family had deep roots in the area. Trumpeting the optimism found in newly developing subdivisions, J. Ivanhoe "Ivan" Rosenberg was a huge supporter of everything southwest Denver. Recognizing the strong connections made between new communities, businesses, and schools, the newspaper was instrumental in helping to create a strong sense of place for this growing region of Denver. (SWDHD.)

STOP THE PRESSES! Ivan Rosenberg sent his kids to neighborhood schools, including West High School. He was witness to an increasing diversity in his section of Denver, as more Hispanics began to move to Barnum, Valverde, and Westwood after World War II. Elected to District 3 on an enlarged city council in 1971, Rosenberg would lose four years later to Sam Sandos, representing the growing clout of the Hispanic community as it spread farther south into southwest Denver. (SWDHD.)

RESULTS OF THE BABY BOOM. With about 3,300 students enrolled in the 1964–1965 school year, the brand-new Abraham Lincoln High School was bursting. Southwest Denver shouted its youthful enthusiasm, confident in the promise that would carry it into the coming decades, just as the automobile carried people away from the common connectivity of the streetcar and exalted in the expression of the individual. With so much happiness to share, who could complain about this packing job? (Lincoln High School.)

A CANDID MOMENT IN TIME, 1965. This moment of fashion, hairstyles, and camaraderie is captured in a boisterous Lincoln High hall. Breezing through the scene, Twila Moon glances back at the photographer—an inquisitive moment in the bustle surrounding her. (Lincoln High School.)

ARCHITECT TEMPLE BUELL'S INTERNATIONAL STYLE MASTERPIECE, 2285 SOUTH FEDERAL BOULEVARD. With pompoms as big as their smiles, the cheerleaders, poised and elegant, capture the excitement and brightness of the mid-1960s. Though tumultuous times were to fill later parts of the decade, these ladies at Lincoln High School rallied the spirit of the moment with their rousing cries, "Raise your hands! Stomp your feet! Lincoln Lancers can't be beat! Go Blue, Go Gray!" (Lincoln High School.)

THAT DECADE HAS ARRIVED, C. 1972. To the Lincoln cheerleader patiently guiding her young charge through the fashions of the moment, the class of 1990 must have seemed as far away as the far side of the moon. Yet the little girl admiring her clean socks and spotless shoes would perhaps inherit the athletic courts one day for some cheerleading of her own. (SWDHD.)

LINCOLN BASKETBALL PLAYERS WITH COACH MELVIN HORNECKER, C. 1972. The sweat of athletes pushing themselves, the squeak and pound of sneakers on the smooth wood of the basketball court—southwest Denver beat with the vigorous strength and energy of its youth. Changes would lie ahead for the neighborhood, in more areas than lengths of basketball shorts, tube socks, and hairstyles. Still, the commonality of athletics still binds people together today, regardless of neighborhood and decade. (SWDHD.)

THOSE KENNEDY GIRLS IN BLUE AND GREEN. The instant rival of Lincoln when it opened at 2855 South Lamar Street in 1966, Kennedy dominated the new neighborhood of Bear Valley. Kennedy's Pep Club is shown reveling with youthful ebullience. While the lessons of high school were certainly not unique to southwest Denver, the skiing, hiking, and other recreational gifts of the nearby mountains could not help but make even the peppiest pep club a little peppier. (SWDHD.)

WHEN THINGS ARE NEW. Suburban life offered a freshness filled with novelties of an increasingly fast-paced age unheard of in previous generations. Young neighborhoods brimmed with remarkable vigor, and gazing upon this captured moment, it is still palpably vibrant. School rivalries seemed livelier, the surroundings free of the dismal decline of decades. Like a colt cavorting with the elation of being alive, southwest Denver kicked up its heels. (SWDHD.)

WHAT $4 MILLION CAN BUY. Kennedy High School rises in the foreground. Covering over 700 acres, Bear Valley was brought into Denver in two large parcels, in 1960 and 1962. The western section of Bear Valley abutted a convoluted boundary along Bear Creek. With the 115-acre annexation of the Green Meadows development north of Bear Valley during these same years, Denver began an aggressive push to annex Jefferson County ranches and developments into its "sphere of influence." (SWDHD.)

DEVELOPERS CAN INFLUENCE POLITICIANS, MAY 4, 1963. Aksel Nielsen and his Mortgage Investment Company also wanted the area annexed to Denver. The city was prepped and ready to keep its middle-class homeowners and businesses inside city limits. With 22 custom builders with prices ranging from $16,000 to $30,000, Bear Valley saw its first home open in July 1961. In this photograph, Sheridan Boulevard runs to the south from middle left to upper right, with new homes rising south of Yale Avenue. (DP.)

AN INDOOR MALL COMES TO SOUTHWEST DENVER. Opening April 1, 1958, on the east side of Sheridan just south of Dartmouth Avenue, the new Bear Valley Mall preceded the construction of any new homes in Bear Valley. However, it sat just south of the massive Harvey Park subdivisions. Sitting on a 30-acre site with 350,000 square feet of space, the mall included a Miller's Supermarket, Hodel's Drugs, Duckwall's Variety Store, and May D&F Department Store. (SWDHD.)

THE MISSING BEARS OF BEAR VALLEY. Dominating the entrance of the Bear Valley Mall, these giant bear statues have disappeared, just as the once-common bears that gave their name to nearby Bear Creek have. Photographs of the brown bear statues, seen here in the background and popular with children in the 1960s and 1970s, are nearly impossible to find. The mall itself is long gone. (SWDHD.)

THE DUKE FAMILY FARMHOUSE. One of the last pieces of undeveloped land within Bear Valley was the site of the Duke family turkey farm. They retained ownership of the farmhouse while selling off much of their land for the new subdivision. Richard Duke was an attorney who worked side by side with area residents in Westwood and Sheridan in seeking to finalize annexation to Denver. He had some successes and some failures in these efforts. (William Marlow.)

WEST DARTMOUTH AVENUE AND SOUTH JOSLIN COURT, C. 1973. Children laugh and play at Bear Valley Park. The growing subdivision rises behind them toward the north. The long greenbelt park stretches along Bear Creek. A connection to the south of the creek was installed for schoolchildren near Lamar Street to connect to the Seven Springs/Academy neighborhood, also in Denver and annexed on December 31, 1971. (SWDHD.)

THE BEAVERS STAYED, THE BEARS LEFT. Bear Valley Park has had its share of run-ins with local beavers who do not seem to mind that a subdivision has been living amongst them since 1960. This picture was taken near South Reed and West Dartmouth during the mid-1970s, showing a large pond that has since been drained. The beavers could access the site from adjacent Bear Creek. Ongoing efforts worked to trap and relocate the beavers. (SWDHD.)

THE MOLLY BROWN SUMMERHOUSE, 2690 SOUTH WADSWORTH BOULEVARD. Margaret Brown of *Titanic* fame called her country home Avoca. She and her husband, J.J., originally owned 240 acres and would visit to escape the busy city. Annexed to Denver March 28, 1966, the remnant farmhouse is all that remains. In the nearby Bear Valley West strip mall sits a longtime denizen of southwest Denver, the Nic-Nac-Nook, Denver's oldest metaphysical bookstore. (SWDHD.)

CENTENNIAL RACETRACK, C. 1952. With Bowles Avenue stretching east into Littleton, the track opened on July 4, 1950. As 10,000 people viewed the races that opening weekend, promoters hoped to create the "Santa Anita of the Rockies." The years were not kind to the track, and despite the best efforts, it closed for good in 1981. To the west of the track, however, Centennial Acres and Centennial Estates subdivisions arose, with their streets named after famous racetracks, such as Monmouth Park, Pimlico, and Tanforan. (AC.)

A SHARK-TOOTH BORDER FOR CENTENNIAL. Annexation wars between Littleton, Englewood, Sheridan, and Denver brought forth a land grab of unprecedented confusion and animosity between city, neighbor, and county. Consequently, the boundaries form a hodgepodge northwest of Federal Boulevard and Belleview Avenue. Denver is represented north of the jagged boundary, with the city of Littleton to the south. The boundary is literally along property lines. Denver's sections still carry Littleton and Englewood mailing addresses to this day. (City and County of Denver.)

FORT LOGAN NATIONAL CEMETERY, C. 1975. Denver's battle with Arapahoe County over the legal annexation of Fort Logan led to acrimonious court battles throughout the 1960s. The subdivisions of Centennial Acres and Centennial Estates, south of Fort Logan, were also threatened with permanent de-annexation if Fort Logan remained outside of Denver. Ultimately, the city prevailed, and after annexing an additional 38 acres of Centennial Estates on December 29, 1969, the city's boundaries in this area were fixed. (SWDHD.)

THE BOYS OF SUMMER, C. 1980. Nothing could be more iconic of summertime than the great American pastime: baseball. The pursuits of suburbia included other activities such as swimming lessons or riding one's bike down to the park after being told to "go outside and play." The Southwest Denver Little League, "developing character and sportsmanship for boys ages 8-15," was based out of Mullen Park, next to Mullen High School. (SWDHD.)

THE YMCA, 2680 WEST MEXICO AVENUE, C. 1975. Located in the Ruby Hill neighborhood, southwest Denver's "Y" relocated to 5181 West Kenyon Avenue across from Fort Logan National Cemetery in 1981. The old location became the Athmar Park Recreation Center (even though it does not even sit within that neighborhood). The new Southwest Family YMCA negotiated a long-term lease with the city on 5.5 acres of land within Bear Creek Park. (SWDHD.)

FEDERAL BOULEVARD DENSIFIES, C. 1976. With Loretto Heights looming in the background, the continuing urbanization of southwest Denver was apparent with the construction of a high-rise senior-living tower at 3000 West Yale Avenue. Known as the Golden Spike, the building made its presence known and joined the Columbine Tower, Louisiana Manor, and Mountain View Tower in providing lower income and senior housing along Federal Boulevard. (SWDHD.)

MAR LEE COMMUNITY GARDEN, C. 1972. The large Mar Lee Manor Shopping Center at the northeast corner of Tennyson Street and Florida Avenue was established in 1956. Businesses included an Eaker's Department Store, Miller's Supermarket, Mar Lee Liquor, Mar Lee Laundry, Mar Lee Beauty, and Dolly Madison Ice Cream. In this photograph, a 4-H volunteer takes part in planting a garden in a former trash-strewn lot on the east side of the center. (SWDHD.)

MAYOR WILLIAM MCNICHOLS VISITS MAR LEE MANOR, C. 1973. Mar Lee, like Athmar Park, now provides its name as the official neighborhood moniker because it was the lucky subdivision name plastered on the strip mall that provided the shopping needs for residents. About 700 homes were built within Mar Lee from 1950 to 1955, including 200 by K.C. Ensor. Like Mayor Currigan before him, McNichols pursued an aggressive annexation policy while simultaneously working to rebuild a depopulating and depressed downtown area. (SWDHD.)

MAYOR MCNICHOLS VISITS BOW MAR HEIGHTS. The mayor digs in at the site of future Denver Fire Station No. 28 at 4306 South Wolff Street, which would open on March 1, 1974. Its service area could not include the town of Bow Mar. Named for early settlers John Bowles and John Marston, Bow Mar was established by King Soopers founder Lloyd King in 1958. Residents hoped to stave off annexation into Denver, which would soon surround it on three sides. (SWDHD.)

FRANK TRAYLOR SCHOOL, 2900 SOUTH IVAN WAY. This modern school opened in 1968 for the children of Bear Valley. In this photograph, engine No. 23 from the Westwood station sits outside helping with a fire drill. With continued growth of Denver through annexation, superior urban services such as fire protection were constantly being touted as reasons to join the city. The Westwood station No. 23 opened in 1951 and Harvey Park's station No. 25 opened in 1957. (SWDHD.)

COLLEGE VIEW'S VOLUNTEER FIRE DEPARTMENT. The Denver Fire Department subsumed local fire districts after annexation took place. The College View fire department covered a larger area than the actual College View annexation; consequently, the fire district covered only three smaller parcels after the 1962 annexation. The fire station stood at 2900 West Bates Avenue. The building, equipment, personnel, and retired firefighters were eventually driven into obsolescence. (SWDHD.)

POLICE DISTRICT 4, 2925 WEST FLORIDA AVENUE, C. 1975. As Denver marched relentlessly southwestward and houses rose on former farm fields, the services necessary to protect citizens rose to meet the need. Police officers and firefighters, already present for the sparse population, were necessarily increased in number, access, and proximity. Safety was on the mind of southwest Denver residents. (SWDHD.)

A Mid-Century Modern Wonder. The original Southwest State Bank stood proudly at Arkansas Avenue, adjacent to the police station on land that had been pasture as recently as 1953 (see page 50). The strip mall in which it was located also contained a brand-new Skaggs Drug Store. The bank was complete with the modern addition of convenient drive-through banking. Locally owned, it was later sold and stripped of its original expressionist facade. (AC.)

Paper or Paper. King Soopers opened its first store in the Denver region in 1947. The family-run grocers of yesteryear, like Miller's or Red Owl, would gradually be absorbed by giants. Centralized food became big business and stores like King Soopers and Safeway became the places for locals' shopping needs. Southwest Denver's participation has been no different, but some things have changed. In former years, the plastic bag was not an option. (SWDHD.)

SOUTH FEDERAL STREETSCAPE, C. 1975. The streets of the Denver area had formerly used separate, unrelated names generally picked by the developer. Beginning in the 1880s and largely finished by 1904, Denver unified and alphabetized much of its street grid: one street, one name, throughout the metropolitan area. Most neighboring cities and counties accepted the grid, meaning Warren Avenue, in the foreground, is the same in the western or eastern part of the Denver region. (SWDHD.)

ADAPTIVE REUSE, 880 SOUTH FEDERAL BOULEVARD, C. 1975. This former house on a rural Federal Boulevard was being reused as a liquor store. With Fire Station No. 23 behind it, Dot's fronted a strip of Federal Boulevard that contained other middle-class businesses during the 1950s through the 1970s, such as Mama Rosa's Italian Restaurant, King's Court Lounge, Taylor Pharmacy, Doc's Liquors, and the Big Top Convenience Store. (SWDHD.)

Rainy Day, Sunday Afternoon, c. 1975. Like much of the rest of the urban growth along South Federal Boulevard during this time, Mid-Century design and architecture were everywhere. The use of neon lighting made these signs stand out to passing cars. Other car-oriented uses are apparent with the ample parking lot and, across Federal Boulevard, a garage, the Cottage Coffee Shop, and a brand-new restaurant named Wendy's. (SWDHD.)

Christmas 1973. Opening over the holidays, the movie *The Sting* enthralled audiences immediately, and the lines to get in were long. The Brentwood Shopping Center, aside from being extremely popular for shoppers in the neighborhoods near Federal Boulevard and Evans Avenue, also had a small movie theater complex. Howell's and Hested's (right) were two of the more popular stores that anchored Brentwood. (SWDHD.)

THE AGE OF THE ORGAN GRINDER, C. 1979. The Alameda Square Shopping Center at South Zuni Street and Alameda Avenue was also kind to cars. The Organ Grinder's time in Denver was brief, but it wowed local children with its giant organ and pizza. Alameda Square had supplanted older Valverde shops when it opened in the early 1950s on 22 acres and with parking for 1,500 cars. Other businesses in the center included King Soopers, Woolworth's, and Walgreen's. (SWDHD.)

"YOU DESERVE A BREAK TODAY," C. 1975. Located at 2120 West Alameda Avenue, this McDonald's restaurant (1960), along with its sister at 3050 West Jewell Avenue (1959) in Brentwood were among the very first McDonald's in the entire state. After seeing the popularity of the restaurant at 1100 South Colorado Boulevard (1957), McDonald's chose to open in other new suburban locations. In this photograph, students hold up pictures of McDonald's hamburgers when only 17 billion had been sold. (SWDHD.)

TRAGEDY STRIKES SOUTHWEST DENVER. The Great Platte River Flood of 1965 devastated communities that abutted the river from south to north. It started on June 14 and lasted for four days. Valverde and old Manchester suffered greatly during the flood. The neighborhoods experienced $500,000 in property damage at the time and had 324 homes condemned. For Denver, its Cherry Creek drainage had historically been the bigger problem, but in 1965, that all changed. (PHS.)

THE BEST VIEW WAS FROM RUBY HILL. Residents were well aware of the tragedy that was about to unfold. The flood effectively cut the southwestern part of town from the city as a whole, with bridges damaged or outright destroyed. Old-timers know just where they were when the flood took place. Many watched from the safety of higher ground as the ill-treated river enacted its own watery revenge on the city. (PHS.)

NO PARKING HERE. According to the *Denver Post*, "[The flood] destroyed or damaged more than 5,000 homes, trailers and farm buildings, and about 6,700 small businesses, leaving in its wake $543 million in damages." It killed 21 people, injured another 600, and dumped 14 inches of rain on areas south of Denver—helping to exacerbate the flood. The town of Sheridan experienced tragedy, as it lost its town hall and many of its early records. (PHS.)

EVACUATE OR ELSE! Pioneer Grace Guth returned to find water damage up to the ceiling line of her Kalamath Street home and her milk can of silver dollars, which she had buried for safe keeping, lost under a pile of rubble. The Centennial Race Track watched as two dozen horses perished in the flood. Two positive developments occurred in the aftermath: the creation of the Urban Drainage and Flood Control District and the construction of Chatfield Dam. (PHS.)

THE CALM BEFORE THE STORM, C. 1973. The incredible mountain view from neighborhoods across southwest Denver is readily apparent in this photograph taken from Bates-Hobart Park. Traylor School (left) and Kennedy High School are pictured. Soon to join the neighborhood in 1975 would be the new S. Arthur Henry Junior High School at 3005 South Golden Way. All eyes and ears in southwest Denver would soon encounter a new issue: school desegregation. (SWDHD.)

WHEN THE SCHOOLS WERE OVERWHELMINGLY WHITE. Students pour out of the new Mary Kaiser School, which opened in fall 1974 at 4500 South Quitman Street, north of Centennial Estates. Kaiser was among the last of Denver's postwar schools to be constructed. It opened at the same time that the federal courts implemented their first busing for integration efforts across Denver. At nearby Sabin, its 1,303 students were 97 percent white in 1968. Kaiser was no different. (SWDHD.)

WAITING TO RIDE A BUS FOR RACIAL INTEGRATION EFFORTS. The schools of southwest Denver were caught off guard when the US Supreme Court declared that all of Denver's schools were intentionally segregated. The majority of southwest Denverites, being in new suburban homes that had been annexed to be within the Denver city limits, argued that their schools were no more segregated than those across the line in neighboring Jefferson and Arapahoe Counties. (SWDHD.)

PARK HILL'S FINEST, C. 1976. At the Dorothea Kunsmiller Junior High School, 2250 South Quitman Way in Harvey Park, racial balance was achieved by busing in students from a satellite area in Park Hill in the blocks surrounding Twenty-Ninth Avenue and Cherry Street. In 1968, Kunsmiller, named for a longtime member of the board of education, was 90 percent white. Through busing, the makeup of the student body was about 60 percent white and 20 percent each black and Hispanic in 1975. Similar plans were established at Kennedy High School. (SWDHD.)

HARVEY PARK WITH KUNSMILLER IN THE DISTANCE. Judges William Doyle and Richard Matsch expanded on integration in 1976. Instead of riding a bus between two schools in one day, they approved a pairing plan. Most southwest Denver schools were paired with minority schools in other parts of the city. Students would attend grades first through third in one neighborhood, and grades fourth through sixth would be in the other. Either way, a student would ride a bus for some of his or her schooling. (SWDHD.)

CHILDREN LEARN THE METRIC SYSTEM, 1970s. Desegregation efforts could not cross school district lines. Consequently, many parents chose to move to Jefferson County or Littleton. Other parents embraced the system. Frances Doull School (1956), Ella Denison School (1960), Charles Schenck School (1958) and Charlotte Godsman School (1957), which were 94 percent, 88 percent, 87 percent, and 86 percent white respectively in 1968, were among targets for integration. Herbert Munroe School (1962) in Westwood, which was 46 percent white in 1968, was among those left alone as naturally integrated. (SWDHD.)

THE MULLEN BOYS ARE BACK. Some parents also chose private schools to escape busing or even as a protest against what they perceived as an intrusive federal government. During these years, enrollment at schools like Mullen High School and Colorado Academy increased. For Mullen, having had its campus shrink considerably over the years, the interest breathed new life into its overall mission. Here, the Mullen Mustangs continue a long and proud tradition in southwest Denver. (SWDHD.)

MULLEN CAMPUS AERIAL. West Kenyon Avenue runs south of the track. With Hampden Avenue bisecting the campus in 1962, the school had to reorganize its land, including eventually selling a parcel for the Westbridge development behind the track. Some of the other land became part of Bear Creek Park. By the late 1990s, very few could even identify the grotto on the old north side of campus. It was unceremoniously demolished and the land prepared for 60 more homes. (SWDHD.)

LUTHERAN HIGH SCHOOL, 3201 WEST ARIZONA AVENUE. Other students chose to attend parochial schools as a way to escape what they saw as the ills of public education altogether, but the hard truths of desegregation were hard to ignore. For many, children of the 1970s and 1980s were used in a grand social experiment that had southwest Denver as part of its laboratory. Though an artificial construct, integration through busing ended up affecting everyone on both sides of the border in southwest Denver. (SWDHD.)

ONE OF THESE THINGS IS NOT LIKE THE OTHERS, MAY 1979. Former school board member Ted Hackworth (left) campaigns for a seat on Denver City Council to represent District 2. With a district bleeding thousands of students each year, the decade of the 1970s ended on a down note. Hackworth also hoped to use the Boundary Control Commission to bring closure to the annexation wars: "What we're trying to do is straighten the lines—some of the worst lines you've ever seen in your life." (SWDHD.)

111

FAMILIES OF SOUTHWEST DENVER, C. 1977. Beer in the cup, baby in the arm, smiles in the sunlight—what are the stories behind the heady times that were the 1970s in southwest Denver? The novelty of its neighborhoods was becoming commonplace, with new trendy spots blossoming elsewhere. Like the stories of these happy families, many chronicles of neighborhoods in change are lost to time. (SWDHD.)

TO THE FUTURE. A nation struggling to come to grips with difficult challenges sought new solutions, such as busing. The children of southwest Denver met the future with winter games, quiet moments on the playground, and the hopeful smiles of friends. The solidarity and mettle of the neighborhoods would be tested by the times to come, but these young fellows were likely willing to give it their best shots. (SWDHD.)

Seven
Planting a Future Denver

Keep Denver School Ties, De-Annexed Area Asks

Englewood, Denver Vie for College View

Grant Ranch Annexation Is Struck Down

City OKs Sheridan Annex Petition

Centennial Estates Files Annex Petitions

3 Suburban Areas Seek Link To Denver; Prepare Petitions

Dis-annexed Area Seeks Way Of Getting Back Into Denver

'Return to Denver' residents' battle cry
Some who were 'moved' to Jefferson County seek reannexation

ANNEXATION 'FOOTBALL'
Friendly Hills Not Befriended

WHEN NEWSPAPERS DOMINATED THE NEWS. For 30 years, Denver remained the king of annexation in Colorado. With overwhelming interest from residents but also taking cues from city planners, landowners, attorneys, and business interests, Denver had a well-oiled annexation machine. This all came crashing down due to a one-woman force—lobbyist Freda Poundstone from suburban Greenwood Village—who vowed to stop the city. With the threat of forced busing now looming over Denver, a perfect storm formed to stop future annexations. (Aaron Marcus/DW.)

FREDA, TRIUMPHANT! The November election of 1974 witnessed 58 percent of Colorado voters force Denver to look inward for its economic salvation. Some argue that the Poundstone Amendment resulted in rejuvenated center-city neighborhoods. On the other hand, the amendment left a wake of haphazard boundaries frozen in time and unprecedented intercounty animosity. Denver officials insisted that the confusing boundaries contributed to inefficient delivery of services, obsolete governing structures, a poor sense of place, and completely incongruent school attendance boundaries. (DPL WHC.)

HARRIMAN LAKE JOINS SOUTHWEST DENVER. The five Fehringer-Harriman annexations of 1973 were quickly followed by the 475-acre Quincy-Alkire annexations, which helped Denver reach all the way to the foothills. The community of Friendly Hills found itself in a no-man's-land of uncertainty after all annexations of this area were ruled invalid in 1976 and Denver lost these developments. Harriman Lake and Friendly Hills' brief relationship with the City and County of Denver came to an end. (DW.)

GRAND PLANS FOR GRANT RANCH. Working with the Grant family, the city pursued two annexations of this property. To comply with the annexation laws of the time, the first parcel jutted out from Marston Lake and then stretched westward in a thin strip. The larger parcel, the so-called Christmas Day Annexation of 1973, was the subject of a bitter war with Jefferson County over the ensuing decade. This c. 1975 photograph shows the historic access to the ranch along Bowles Avenue. (SWDHD.)

"I've got good news. We've finally decided you belong to Jefferson County. Now for the bad news..."

JEFFERSON COUNTY FIGHTS BACK AND WINS. Only the initial Grant Ranch annexation was upheld in May 1977 by the Colorado Supreme Court. By July 1981, the courts prohibited Denver from reannexing the larger parcel. This was brought about by 1,130 residents of Governor's Ranch and Westridge subdivisions—over 70 percent of homeowners—that petitioned Denver for reannexation. According to the *Rocky Mountain News*, residents were "drawn by Denver's lower property taxes, lower sewer and water charges and . . . trash pickup." (Sentinel Newspapers.)

115

THE BEST-LAID PLANS. The city's comprehensive plan from 1978 focuses heavily on land use, parks, and facilities. For southwest Denver, recently annexed areas were integrated into the plan, including the 267-acre West Marston parcel southwest of Quincy Avenue and Wadsworth Boulevard brought in on August 3, 1972. Some plans for Grant Ranch, Governor's Ranch, Westridge, Glenbrook, Village West, and Park West subdivisions included the construction of a library, six elementary schools, and two junior high schools. (Denver Planning Office.)

WHEN GRANT RANCH BECAME RACCOON CREEK, 1996. Perhaps not coincidentally, when busing ended in 1995, plans were made to develop the western end of Grant Ranch. Developers split Raccoon Creek among three jurisdictions. Denver and Jefferson County taxpayers each paid for schools that were across the street from one another, despite the fact that only one was needed. For the rest of the parcel, the Grant family's home became the clubhouse for the new Raccoon Creek Golf Course, which straddles the border. It opened in 1984. (AC.)

WHEREFORE ART THOU, BORDER? Bounded by Crestline Avenue, Wadsworth Boulevard, Cross Drive, and Estes Street, the western end of the small finger of land that remained in Denver contains auto-oriented retail and the Willow Ranch Condominiums. It juts into the rest of Governor's Ranch, which the city lost. Denver had already planned a large park within the subdivision, but as this photograph indicates, with the fence line as its border, it built condos instead, while the piece that developed as Governor Grant Park remained in Jefferson County. (MRP.)

STRUGGLING FOR A SENSE OF PLACE. This whole region still carries a Littleton mailing address. While Denver Fire Station No. 30 and the Southwest Denver Recreation Center are located here, they now serve a much smaller area, including Glenbrook. This subdivision sits farther west than anywhere in the city and county of Denver. In this photograph, the southern point of the fence line across Kipling Street contains the highest point in Denver County at 5,688 feet—an unceremonious blip on the high plains of southwest Denver. (MRP.)

COLORADO ACADEMY, 3800 SOUTH PIERCE STREET. The arbitrary boundaries are not limited to Grant Ranch. The Wellborn Ranch's 94 acres became the site of Colorado Academy in 1947. Adjoining it to the south is the Pinehurst Country Club, annexed to Denver on December 15, 1969. The whole area between Sheridan and Wadsworth Boulevards contains a mishmash of tiny annexations and unincorporated lands. Consequently, it is nearly impossible to know which jurisdiction one is in since all share Denver's zip code 80235. (MRP.)

DENVER IS FORCED TO LOOK INWARD. In the end, Denver could no longer look to the edge of town for economic salvation. It took a while, but Denver has not only prospered—it has thrived. A greater diversity of faces with a wider range of strengths has risen to meet the challenges. Southwest Denver has not yet seen the meteoric renewal the other quadrants of the city have enjoyed. But it surely stands poised to reclaim its place in the wider city's esteem with vitality untapped and undiscovered. (SWDHD.)

Eight
The Undiscovered Country

Fair Hill Landmark, 1978. Farmhouses, symbols of the rural past of southwest Denver, were becoming more difficult to find by 1980. Many believe that had there been more of a push to preserve this heritage, such as the Fair Hill Farmstead, the city would be better for it, since the farm and its outbuildings sat on 69 acres behind Loretto Heights. Arson and neglect led to a subsequent demolition of everything to make way for the Dartmouth Heights subdivision and Loretto Heights Park. (SWDHD.)

THE TACO HOUSE SIGN, 581 SOUTH FEDERAL BOULEVARD. The 1950s brought a new kind of roadside architecture to the forefront as businesses out-competed one another with eye-popping neon signs, unique architecture, and bold design intended to entice an increasingly auto-dependent suburban clientele to stop in. This 1957 gem is one of the few neon signs left along this stretch of Federal Boulevard. The Crown Lanes sign at 2325 South Federal Boulevard is another remnant sign from a bygone era. (MRP.)

ANNA LAURA FORCE SCHOOL (1955), 1550 SOUTH WOLFF STREET. Denver's elementary schools built during the 1950s and early 1960s all exhibit the same International Style design principles. Even John B. Rishel Junior High (1959), built next to Valverde School, offers a lesson in contrasts in architecture. The schools of southwest Denver stand as a testament to the history of the area, from baby boom to baby bust, from split sessions to desegregation—these well-built schools have stayed. (MRP.)

BUENA VISTA! Mountain views abound in Huston Lake Park (pictured), as well as in Garfield and Harvey Park Lakes. Nearby Erb Place is named for Athmar Park developer Raymond Erb and his wife, Margaret, whose family confirms their connection. Perhaps this is the origin of the "mar" in Athmar Park. Despite extensive neighborhood lore and numerous assertions in books, no connection to a mysterious Athena could be authenticated. Census records and discussions with other area developers' descendants show the "ath" in Athmar to be a mystery. (MRP.)

MAR LEE'S "COLORADO SUNSET" AT SANDERSON GULCH. Foreign words are often anglicized as they are drawn into English. In Denver, this issue has manifested itself in local street name pronunciation. Old-timers pronounce Tejon Street as "TEE-hone." New arrivals sometimes say "TAY-hone." The difference marks natives from newbies and creates a lively debate of tradition versus modern preferences and sensibilities. Local pronunciations of Umatilla (YOU-ma-till-a), Zuni (ZOO-nigh), and Vallejo (vuh-LAY-ho) will mark a person's status. (MRP.)

THE CHAMPION OAKS OF CENTENNIAL ACRES. Homesteader and farmer Sam Brown planted numerous oak trees along an agricultural ditch and railroad line back in the 1870s that would eventually grow into some of the largest specimens in the state. The trees on the Englewood side of the Denver boundary include this behemoth at 3084 West Tufts Avenue. When the subdivision was platted, these trees were incorporated into backyards. The trees that remain anchor Denver to the days of the homesteaders. (MRP.)

SOUTHWEST DENVER'S OLDEST BUILDINGS. Denver's active building preservation program includes only one locally registered landmark in all of southwest Denver: the Field Officer's Quarters at 3742 West Princeton Circle. Fort Logan has managed to retain its oldest buildings of officer's housing, which are now used as part of the Colorado Mental Health Institute. Landmark No. 191 is an interpretive museum of Fort Logan's history and is operated by the Friends of Historic Fort Logan. (MRP.)

A Historic District for Cliff May? Area residents are currently studying whether there should be a historic district to protect this largely intact subdivision within Harvey Park before the homes are altered beyond recognition or scraped altogether. The neighborhood is now over 60 years old, which gives residents one more reason to consider local landmark designation. These gems are quintessential examples of Mid-Century Modern ideals and are currently diamonds in the rough waiting to be rediscovered. (Atom Stevens.)

Private Access at Wolcott Lake. Hidden among the homes of southwest Denver are beautiful lakes and quiet lanes. Lakeridge Road begins at Tennyson Street and runs west with the old agricultural ditch still visible. Only residents of the area have access to the lake. This arrangement speaks to the can-do attitude of early residents who had the means to bypass the city to provide recreational activities. Another example was the private-access Terrace Club Swimming Pool, now gone. (MRP.)

THE IRIS FARM OF COLLEGE VIEW. Southwest Denver neighborhoods are not completely devoid of their farming past. The Boulevard Gardens, Southlawn Gardens, and Evans Park Estates areas of the College View neighborhood retain, in many cases, the large half-acre and acre lots that attracted new residents a century ago. Chickens, gardens, and larger farmed acreage are still apparent, including the popular iris farm at 2700 West Amherst Avenue, which cultivates its three acres around a large modern farmhouse. (MRP.)

THE GHOSTS OF THE ALLEN FARM. Other remnants of the farming past linger in additional ways. The greenbelt of the Trapper's Pond neighborhood southwest of Belleview Avenue and Simms Street winds along the lane that accessed the farmhouse for the C.J. Allen farm (see page 80). Included on this path is a large cottonwood that is a remnant from that time. Although Denver did not ever annex this site, it came close, annexing parcels just to the north and south. (MRP.)

IF THIS GATE COULD TALK. One of the oldest remaining artifacts that can be tied back to the origins of Denver graces the site of a cemetery at the rear of the Loretto Heights campus. The gate traces its roots back to St. Mary's Academy, which opened in 1864 in downtown Denver. When the sisters came out to Loretto Heights, the gate came with them. The cottonwoods that ran along the agricultural ditch are still in the distance. (MRP.)

MODERNIZE THE BOUNDARY! In light of shared history, citizens and legislators are urged to cooperate in bringing about more consistency to shared borders by using the Boundary Control Commission. For many, using major streets in lieu of property lines and aligning zip codes and city names to the actual boundaries of Denver would go a long way to improving the sense of place on both sides of the Denver County boundary. It could also result in more efficient and cost-effective delivery of services for everyone. (Ken Schroeppel.)

Nuestra Valle Verde. When Joseph Fassett looked down from the high promontory that would become his home, he was surely inspired by the ribbon of green below. Perhaps named for a Spanish-flavored nod to the green valley or maybe the surname of a friend, "Val-verd"—along with a growing city—would never remain one people or one culture. Southwest Denver, if nothing else, has always been changing. (SWDHD.)

A Nod to the Past. The old Valverde School is gone, but steps remain. Each generation has continued to pass on shared memories to the next. C.J. Allen (see page 25), with an uncharted future ahead, might never have imagined his great-grandson authoring a book about the neighborhood and city he knew throughout his life. The present residents tip their hats to C.J. and all the people from the past who helped sow the seeds of today's magnificent southwest Denver. (MRP.)

BIBLIOGRAPHY

Autobee, Robert. *If You Stick with Barnum: A History of a Denver Neighborhood.* Denver: Colorado Historical Society, 1992.
Ballard, Jack Stokes. *Fort Logan.* Charleston, SC: Arcadia Publishing, 2011.
Brenneman, Bill. *Miracle on Cherry Creek.* Denver: World Press, Inc., 1973.
Casey, Sister M. Celestine and Sister M. Edmond Fern. *Loretto in the Rockies.* Denver: Loretto Heights College, 1943.
Catlett, Sharon R. *Farmlands, Forts, and Country Life: The Story of Southwest Denver.* Boulder: Westcliffe Publishers, 2007.
Currigan, Thomas G. Papers, 1955–1969. Denver Public Library.
Denver Municipal Facts. Denver: City and County of Denver, 1909–1931.
Goodstein, Phil. *Denver Streets: Names, Numbers, Locations, Logic.* Denver: New Social Publications, 1994.
———. *South Denver Saga.* Denver: New Social Publications, 1991.
———. *Spirits of South Broadway.* Denver: New Social Publications, 2008.
Noel, Thomas J. and Stephen J. Leonard. *Denver: Mining Camp to Metropolis.* Niwot: University Press of Colorado, 1990.
Planning Toward the Future: A Comprehensive Plan for Denver. Denver: City and County of Denver, 1978.
Simmons, R. Laurie and Thomas H. Simmons. *Historic Residential Subdivisions of Metropolitan Denver, 1940–1965.* Denver: Front Range Research Associates, 2011.
Smiley, Jerome C., ed. *History of Denver.* Denver: Times-Sun Publishing Co., 1901.
Stevens, Atom. "All in the Family." *Modern in Denver* (Winter 2015): 122–139.

Discover Thousands of Local History Books Featuring Millions of Vintage Images

Arcadia Publishing, the leading local history publisher in the United States, is committed to making history accessible and meaningful through publishing books that celebrate and preserve the heritage of America's people and places.

Find more books like this at
www.arcadiapublishing.com

Search for your hometown history, your old stomping grounds, and even your favorite sports team.

Consistent with our mission to preserve history on a local level, this book was printed in South Carolina on American-made paper and manufactured entirely in the United States. Products carrying the accredited Forest Stewardship Council (FSC) label are printed on 100 percent FSC-certified paper.

MADE IN THE USA